Also by Billy Showell:

078-1-78221-082-5

078-1-84448-452-2

WATERCOLOUR
FRUIT & VEGETABLE
PORTRAITS

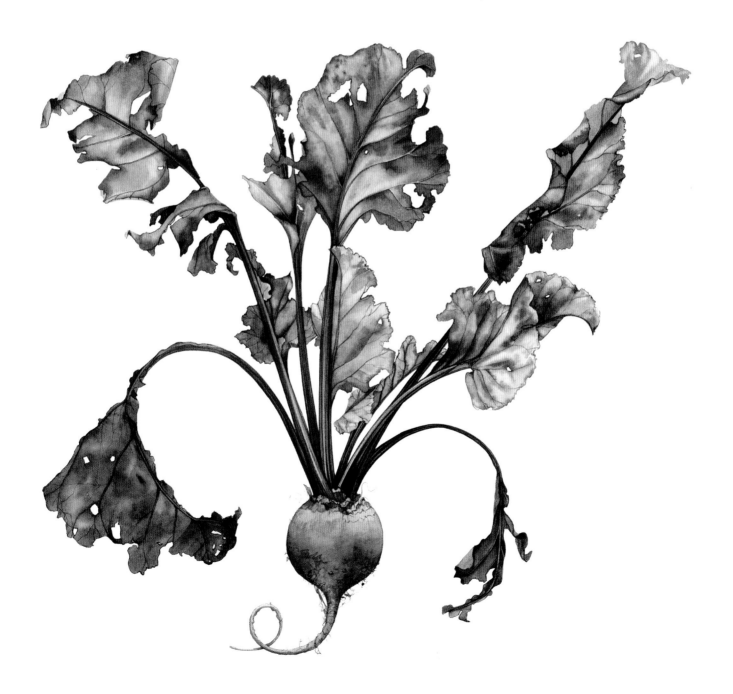

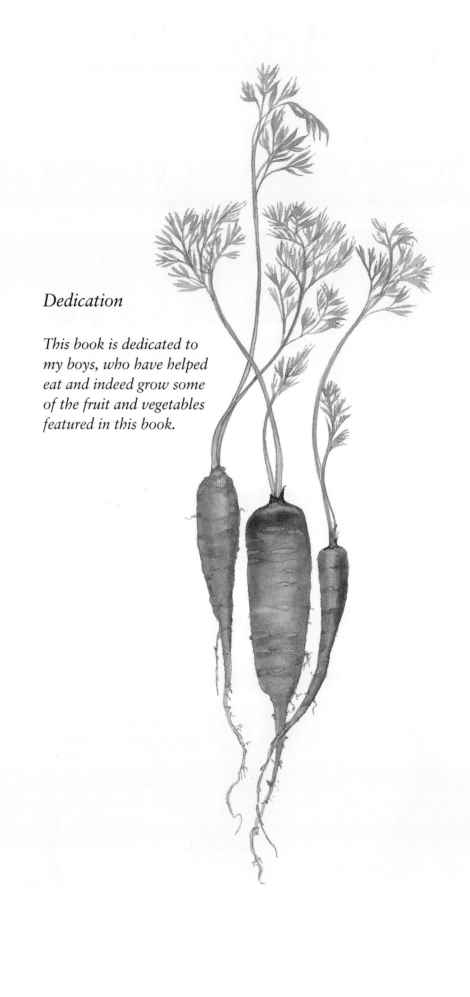

Dedication

This book is dedicated to my boys, who have helped eat and indeed grow some of the fruit and vegetables featured in this book.

WATERCOLOUR FRUIT & VEGETABLE PORTRAITS

BILLY SHOWELL

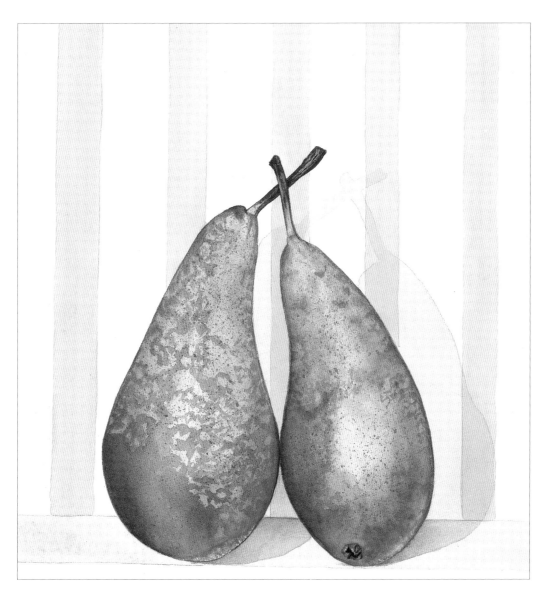

SEARCH PRESS

First published in paperback in Great Britain 2014

Search Press Limited
Wellwood, North Farm Road,
Tunbridge Wells, Kent TN2 3DR

Reprinted 2015, 2017, 2018

First published in hardback in Great Britain 2009

Text copyright © Billy Showell 2009

Photographs by Debbie Patterson, Search Press Studios;
and Pratt Contemporary Art.

Photographs and design copyright © Search Press Ltd. 2009

ISBN PB: 978-1-78221-083-2
ISBN HB: 978-1-84448-272-6

The Publishers and author can accept no responsibility for any
consequences arising from the information, advice or instructions given
in this publication.

Suppliers

If you have difficulty in obtaining any of the materials and equipment
mentioned in this book, then please visit the Search Press website for
details of suppliers: www.searchpress.com

Alternatively, you can visit the author's website:

www.billyshowell.co.uk

or you can write to Winsor & Newton requesting a list of distributors:

Winsor & Newton, UK Marketing,
Whitefriars Avenue, Harrow, Middlesex HA3 5RH

Publishers' note

All the step-by-step photographs in this book feature the
author, Billy Showell, demonstrating how to paint fruit and
vegetables. No models have been used.

There is reference to sable hair and other animal hair brushes
in this book. It is the publishers' custom to recommend
synthetic materials as substitutes for animal products
wherever possible. There is now a large number of brushes
available made from artificial fibres and they are satisfactory
substitutes for those made from natural fibres.

Printed in China through Asia Pacific Offset

Acknowledgements

*I would like to thank Mum and Dad for their help
and support and home-grown vegetables; Jude
for the use of her allotment; Katie, who helped
translate my English into English; Simon for all
his patience and support; and a special thank you
to Grandma, Nanna and my godmother Sarah,
who are no longer here but will always be a huge
influence and inspiration in my life.*

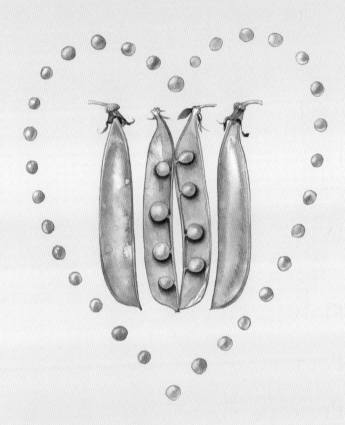

Front cover
Rainbow Chard and Sweet Pea
35 x 55cm (13¾ x 21¾in)

Page 1
Beetroot (Beet)
50 x 50cm (19¾ x 19¾in)

Page 2
William's Carrots
10 x 24cm (4 x 9½in)

Page 3
Two Pears
16 x 20cm (6¼ x 7¾in)

Page 5
Cabbage on the Run
30 x 55cm (11¾ x 21¾in)

Contents

Introduction

One of the things I love about painting fruit and vegetables is that if you are quick enough at painting them you can cook them afterwards, so there is no waste. In some cases, however, this can be a drawback: when my boys were younger, the temptation of fruit sitting on my painting table was too much and I would often come back to finish a painting only to find the fruit missing or half eaten!

I have never analysed why I enjoy painting fruit and vegetables, but the shape of a pear or an aubergine (eggplant) is beautiful and the smooth texture of the skin simply compels me to paint it. My guess is that we all have an unconscious impulse to create images of the food we need in order to live – symbols of health, good living and the beautiful world about us, just as cavemen felt driven to produce paintings of wild animals.

Writing a book on how to paint fruit and vegetables was an exciting and yet daunting prospect. It was easy for me to imagine, yet once I settled down to choose which techniques to demonstrate and what plants to depict I realised what a huge variety of shapes, textures and colours was available to me, and I suddenly felt it to be an impossible task. Eventually I chose to illustrate the fruit and vegetables I could most easily lay my hands on. With a little help from my friends' allotments and trips to markets at home and on holiday, I assembled a good range of subjects for my paintings. On completion of the book, however, I could not help thinking that another three or more volumes were needed to cover all the fruit and vegetables that I adore to paint. I have also included some blossoms in the book, for they seem to me a promise of good things to come, and offer a means of adding colour and interest to a painting.

Taking care of a fruit or vegetable during the time needed to paint it is beset with difficulties; too often in my house the subject of an ongoing study has been accidentally chopped up and put into a dish for dinner. My advice is to label items very clearly with 'do not eat' before you put them in the fridge. Keep small subjects fresh by placing them in a plastic container with a layer of wet kitchen towel in the bottom. Lay them out carefully without letting them touch each other, seal with a lid and keep them in the fridge in-between painting sessions.

Some subjects obviously require longer to paint than others, due to their sheer size or complexity. In my experience, the first few specimens usually end up in the compost, so the painting may require several items to be picked or purchased. Taking a photograph of the original fruit or vegetable may help ensure continuity, but back this up with notes and sketches, as photographs rarely capture the exact colour, tone and depth of shadow. Some of the brassicas give off a nasty smell after several days and therefore require speedy painting.

Capturing the intrinsic beauty of anything from a stunning green cabbage to a single ripe cherry is an art that anyone can master, given the right guidance and a spark of inspiration. This book, I hope, supplies both in equal abundance, so please join me in celebrating the wonderful variety of fruit and vegetables by painting beautiful portraits of them.

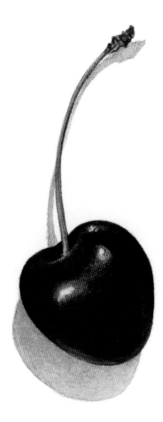

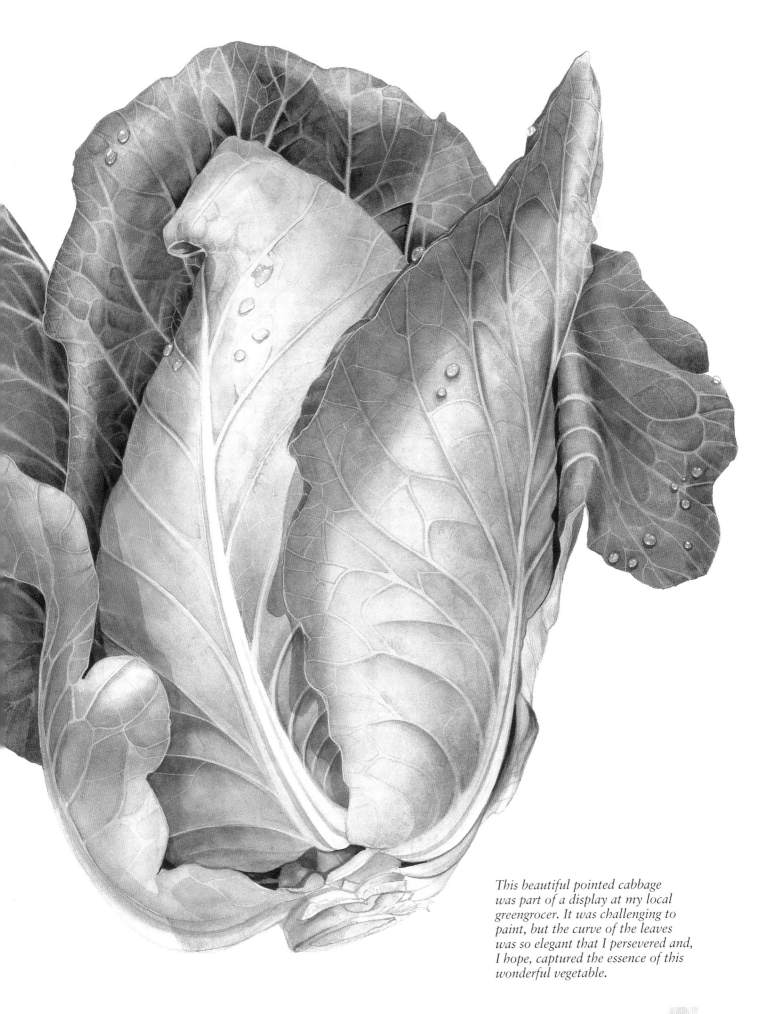

This beautiful pointed cabbage
was part of a display at my local
greengrocer. It was challenging to
paint, but the curve of the leaves
was so elegant that I persevered and,
I hope, captured the essence of this
wonderful vegetable.

What you need

Paints

I always recommend using artists' quality watercolour paints, even if you are a beginner. Cheaper paints give less satisfactory results, whereas good quality paints will spread and flow beautifully on the paper. I prefer to use tubes rather than blocks; this avoids having to wait for the paint to soften before you are able to use it, and paint squeezed from a tube is far better for creating rich, dark mixes.

Paper

The quality of the watercolour paper you use can greatly affect your final painting. Initially, I would recommend buying one sheet of paper at a time until you find the type best suited to your style of work, but remember to note down the make and weight of each one and the results you achieved for future reference.

I predominantly use a slightly off-white, 100 per cent cotton, hot-pressed paper, which has a smooth surface. I always use the side of the paper on which the watermark is printed as this seems to give better results when laying wet-into-wet glazes. A good weight of paper when starting out would be 300gsm (140lb), though I personally prefer to use a 600gsm (300lb) paper. Other, more textured, papers are available, known as rough and NOT (or cold-pressed) papers. These are all excellent but it is hard to get a smooth edge and apply detail.

Palette

A relatively new discovery for me is my ceramic palette, which has replaced my much-loved plastic-lid palette that I now use only when painting on holiday. The ceramic palette is the same shape and size as the plastic version so the layout of my colours remains unaltered, but its smoother surface is therefore kinder to my brushes and is perfect for making wonderful puddles of paint.

These three brushes are all you need to create the paintings in this book. They are, from top to bottom, a No. 4 round sable brush, a No. 6 round sable brush and a No. 12 mixed-fibre brush.

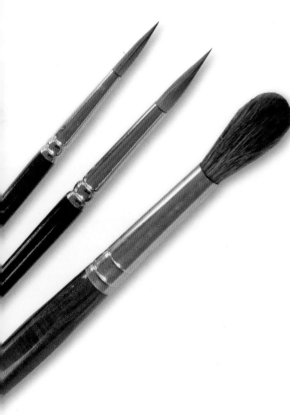

Paintbrushes

You will need three types of brush for painting fruit and vegetables – a No. 4 and a No. 6 round sable brush, which both have an adequate point and good handling qualities, and a No. 12 mixed-fibre brush for covering larger areas. My own brush has a superb point that keeps its shape and can be used to paint minute details such as single hairs. It also holds a large amount of paint and is therefore ideal for laying washes.

Other equipment

Use a good quality, sharp **HB pencil** for drawing, though you could also use a fine, rotary pencil. For removing pencil lines and correcting drawing mistakes I prefer to use a plastic pencil **eraser**, which I cut into a point for more accurate work. You may, though, prefer to use a putty eraser, which may be gentler on the paper. A **scalpel** is useful for sharpening pencils and for scratching out highlights.

Masking fluid, applied with a small, fine-tipped paintbrush, is a good way of protecting areas while you paint over them. I use masking fluid only when absolutely necessary as I find that sometimes the sharp edges created can give a rather flat result. Another useful medium, which I discovered when painting strawberries, is **lifting preparation**, and it has since become useful

for all kinds of tricky subjects. It essentially allows dry washes to be lifted more easily. It is worth trying it out in your sketchbook first as it creates quite a volatile surface to paint on to.

A roll of **kitchen towel** is useful for dabbing your paintbrush on in order to remove excess water. I use plain white paper, as the ink from a patterned variety may come out and be transferred from the brush to your painting. One of my students recommended using a piece of **soft cotton cloth** instead, as it is kinder to the brush and the environment. Old cotton handkerchiefs are good, or pieces of old cotton sheets. Another student of mine revealed a wonderful product to me (she had been introduced to it in another class) – the **magic eraser block.** This is a soft, micro-fibre sponge that can be used to remove splashes of paint from the paper. I wet a small piece of the block, remove the mark and then very quickly dry the patch with some clean kitchen towel or a piece of cotton cloth. This is not, however, suitable for use on areas that you subsequently need to paint as it does slightly raise the surface of the paper; use it with care.

I have an abundance of glass and ceramic **tea-light cups;** once the candle has burnt away the little container makes an excellent mixing bowl for larger washes of colour. I use these cups, for example, to mix large amounts of green when I have a number of leaves to paint. If the paint dries out it is easily enlivened with the addition of some water ready to use another day.

Other items of equipment you will need are a large **water pot**, filled to the top so that you can paint for longer periods without having to change the water; a **magnifying glass** for those times when you need to study your subject in detail; a small **sketchbook** for jotting down notes and observations and for sketching; and a good **desk lamp.** I rescued my lamp from a skip. I had it checked by an electrician and it was fine. The beauty of this lamp is its height – at 70cm (27½in) tall I can achieve a huge variety of shadows with it. Being a 50W halogen lamp, the light is bright and creates a clean, sharp light that is easy to work with.

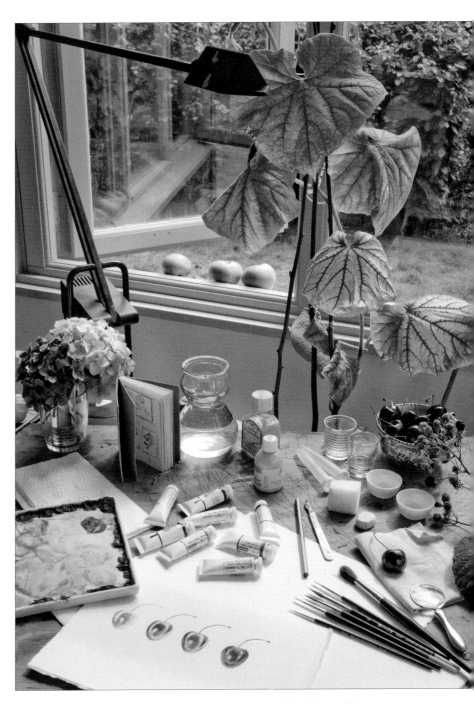

This photograph, taken by the window of my studio, shows all the items you need for painting watercolour portraits of fruit and vegetables.

A magnifying glass is extremely useful for observing minute details.

Drawing

Drawing is given an almost mythical status by some, as though one is either born with the ability to draw or not. Artistic talent often does run through families, but I have observed that it is artistic drive and passion that is inherited rather than ability, and that this drive creates the desire to learn in order to improve and develop artistic skills. I therefore believe that, given time, practice and instruction on what to observe, drawing skills can be mastered even by those with no confidence or belief in their inherent talent.

Understanding the structure of a plant before you begin drawing it is essential. Observe the plant as if you have never seen it before; inspect it thoroughly, make notes and draw sketches, and familiarise yourself with the various textures, patterns and unusual features that you may previously have overlooked through familiarity, such as the spiral alignment of the leaves or a twist along the veins of the stem.

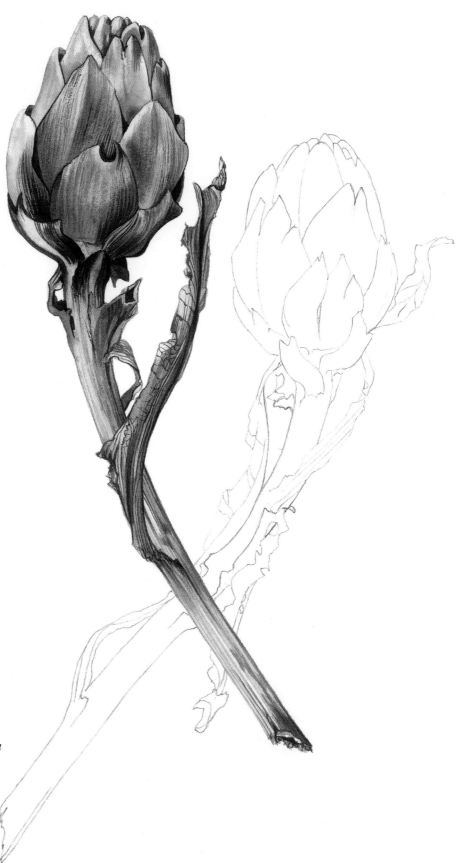

Artichoke

The artichoke is a good example of the spiral formation; the triangular scales of the edible bud lie in a spiral pattern that is easy to see, and which helps you reproduce the form of the artichoke on paper. Used widely in history as inspiration for architectural detail, the artichoke is always a delight to depict. I find it essential to very lightly draw in the centre vein of each of the scales to help gauge the width; these are not always visible but you can get an indication of where they lie from the shadow and the central indentation at the tip of each scale. The space between the stem and the lower leaf is also an important guide to achieving an accurate drawing. Visualise this space on its own; it is an unfamiliar shape, so one is able to draw it with no preconception of what it should look like. Drawing by observation alone, without making assumptions based on preconceived ideas, usually results in greater accuracy.

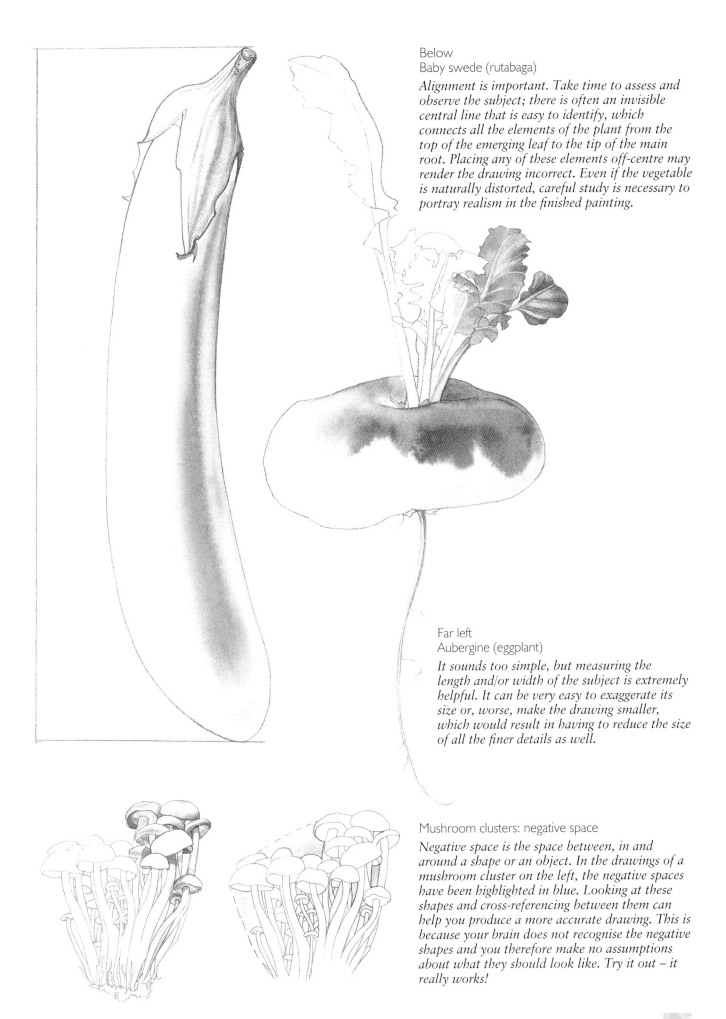

Below
Baby swede (rutabaga)

Alignment is important. Take time to assess and observe the subject; there is often an invisible central line that is easy to identify, which connects all the elements of the plant from the top of the emerging leaf to the tip of the main root. Placing any of these elements off-centre may render the drawing incorrect. Even if the vegetable is naturally distorted, careful study is necessary to portray realism in the finished painting.

Far left
Aubergine (eggplant)

It sounds too simple, but measuring the length and/or width of the subject is extremely helpful. It can be very easy to exaggerate its size or, worse, make the drawing smaller, which would result in having to reduce the size of all the finer details as well.

Mushroom clusters: negative space

Negative space is the space between, in and around a shape or an object. In the drawings of a mushroom cluster on the left, the negative spaces have been highlighted in blue. Looking at these shapes and cross-referencing between them can help you produce a more accurate drawing. This is because your brain does not recognise the negative shapes and you therefore make no assumptions about what they should look like. Try it out – it really works!

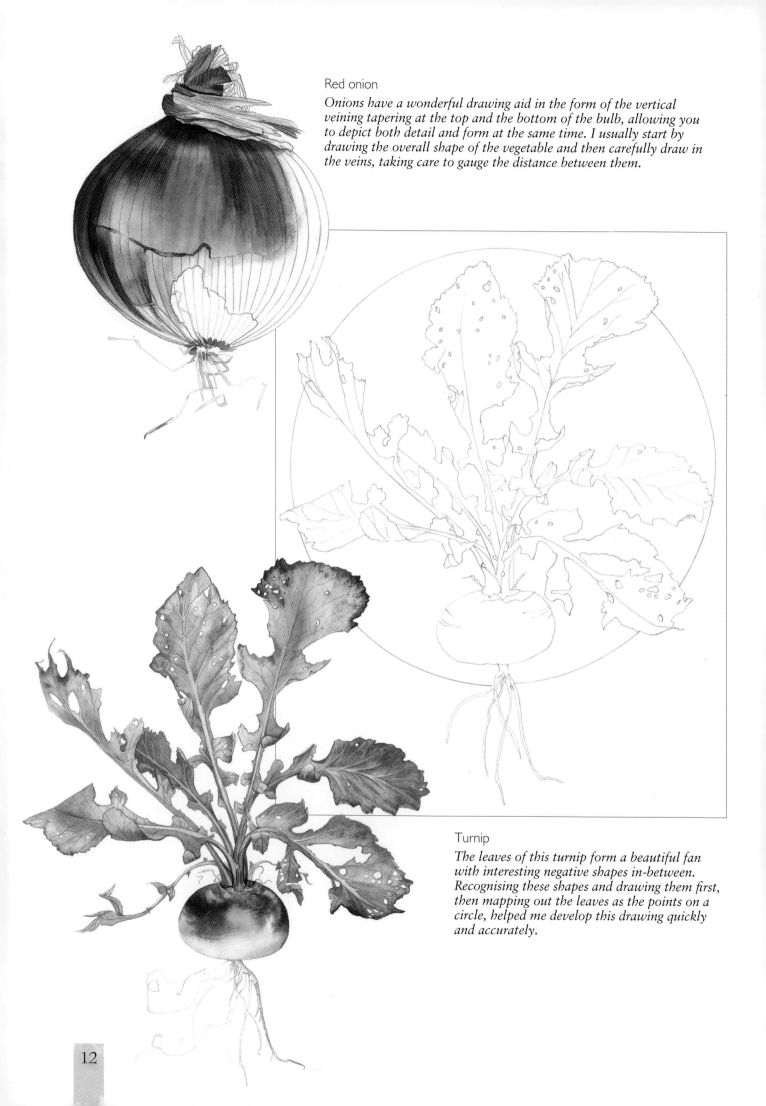

Red onion

Onions have a wonderful drawing aid in the form of the vertical veining tapering at the top and the bottom of the bulb, allowing you to depict both detail and form at the same time. I usually start by drawing the overall shape of the vegetable and then carefully draw in the veins, taking care to gauge the distance between them.

Turnip

The leaves of this turnip form a beautiful fan with interesting negative shapes in-between. Recognising these shapes and drawing them first, then mapping out the leaves as the points on a circle, helped me develop this drawing quickly and accurately.

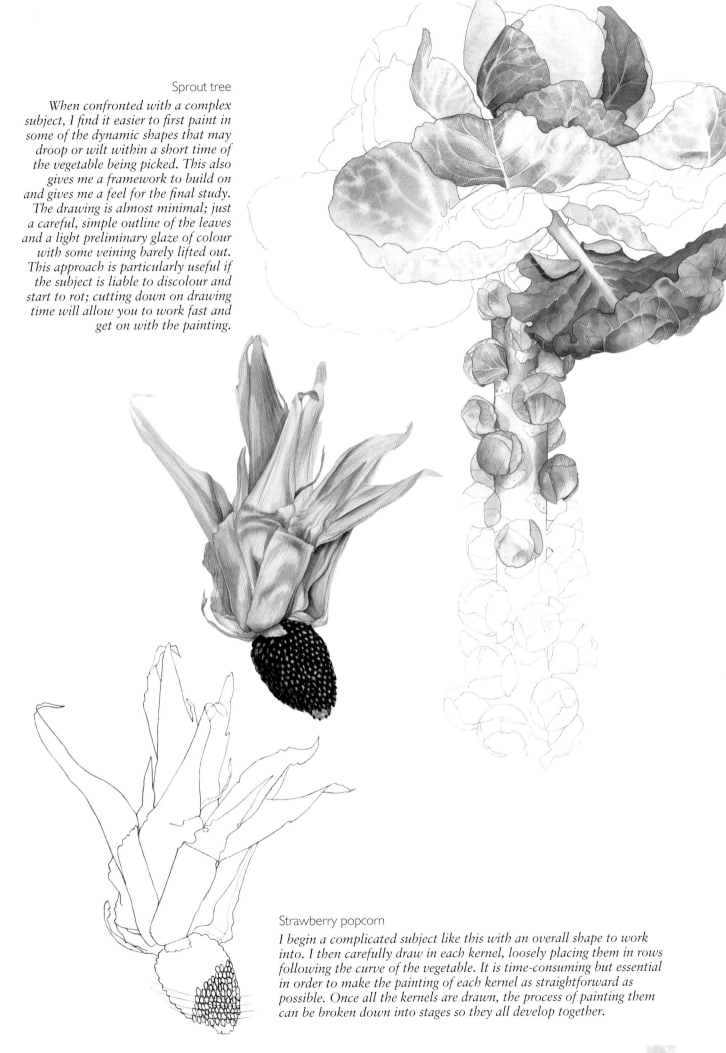

Sprout tree

When confronted with a complex subject, I find it easier to first paint in some of the dynamic shapes that may droop or wilt within a short time of the vegetable being picked. This also gives me a framework to build on and gives me a feel for the final study. The drawing is almost minimal; just a careful, simple outline of the leaves and a light preliminary glaze of colour with some veining barely lifted out. This approach is particularly useful if the subject is liable to discolour and start to rot; cutting down on drawing time will allow you to work fast and get on with the painting.

Strawberry popcorn

I begin a complicated subject like this with an overall shape to work into. I then carefully draw in each kernel, loosely placing them in rows following the curve of the vegetable. It is time-consuming but essential in order to make the painting of each kernel as straightforward as possible. Once all the kernels are drawn, the process of painting them can be broken down into stages so they all develop together.

Pineapple

The pineapple appears complicated to draw; however, if you view the main body of the fruit as a series of boxes, this will simplify the task. Start with the most significant section or easily identifiable part and mark it on the fruit with a spot of red paint. Draw this part as simply and accurately as you can, eliminating surface texture or markings, and mark the same spot on the drawing with a pencil cross (this will be removed later; it is shown here in red to make it easier to see). Then, taking one section at a time, start to map in the areas adjacent to this central piece; if you lose your position you can simply trace your way back from the red spot.

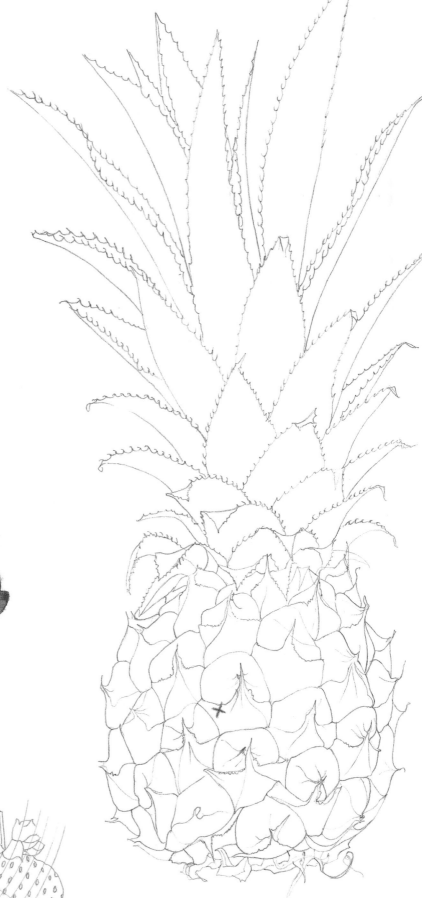

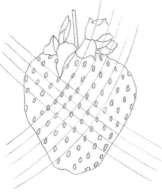

Strawberries

Recognising patterns in seed or petal distribution is an essential aid to achieving realism in your paintings. Here, all the pips are roughly the same size, though they change angle slightly as they wrap around the fruit.

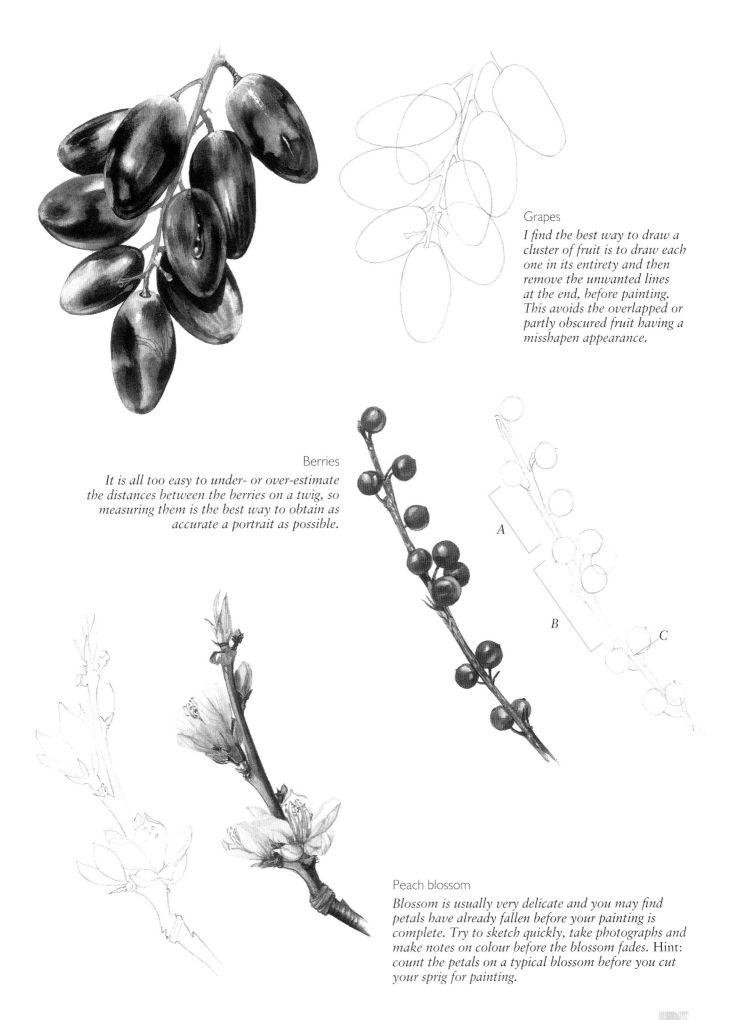

Grapes

I find the best way to draw a cluster of fruit is to draw each one in its entirety and then remove the unwanted lines at the end, before painting. This avoids the overlapped or partly obscured fruit having a misshapen appearance.

Berries

It is all too easy to under- or over-estimate the distances between the berries on a twig, so measuring them is the best way to obtain as accurate a portrait as possible.

A

B

C

Peach blossom

Blossom is usually very delicate and you may find petals have already fallen before your painting is complete. Try to sketch quickly, take photographs and make notes on colour before the blossom fades. Hint: count the petals on a typical blossom before you cut your sprig for painting.

Composition

Creating an interesting arrangement of elements in a painting is paramount to me. Sometimes it happens quite by chance, but most of the time it is through careful planning. In general, the more complicated the subject, the more planning is required, though even the simplest compositions require careful positioning of the various elements on the paper. In all cases, however, there is a source of inspiration: perhaps a single creative thought; the shape or colour of the fruit or vegetable itself; or perhaps simply the realisation that there is another way of viewing an otherwise familiar object.

The particular fruit or vegetable you choose to paint is personal to you. I tend to paint those I find most appealing, and the subjects that will create the most interesting, dynamic or even amusing compositions. I have always been particularly drawn to green fruit and vegetables – creating the correct colour so that they appear edible is always challenging – but I am currently obsessed with black or purple varieties.

Try buying produce from an independent greengrocer or, if you can, grow your own – they usually have more character than the often too-perfect offerings at the big supermarkets. A knobbly lemon is far more interesting than a perfectly smooth one.

There are occasions when I can visualise a composition but cannot find the time to start the painting. In cases like this, I sketch out the idea and hope that one day I will find the time and inspiration to implement it. For this reason, I keep a little sketchbook and paintbrush with me at all times so that I can record my ideas and explore them at a later date back in my painting studio. This is also useful for planning paintings of fruit and vegetables that are currently out of season.

Planning a painting

1. Start by making small sketches of the subject and any supporting material.

2. Notice any particular characteristics of the fruit or vegetable that you can accentuate or highlight.

3. Make small outline drawings of the painting's shape, for example square, rectangle, portrait or landscape.

4. Sketch in various arrangements; no detail is required, just rough outlines.

5. Choose the best and perfect them.

6. Before drawing the composition on to paper, draw a light outline 3–4cm (approx. 1½in) in from the edge of the paper to remind you not to place the image too close to the edge, where the mount card will go.

My sketchbook provides me with a means of recording my ideas and observations when away from my studio, providing a source of inspiration and reference for future projects.

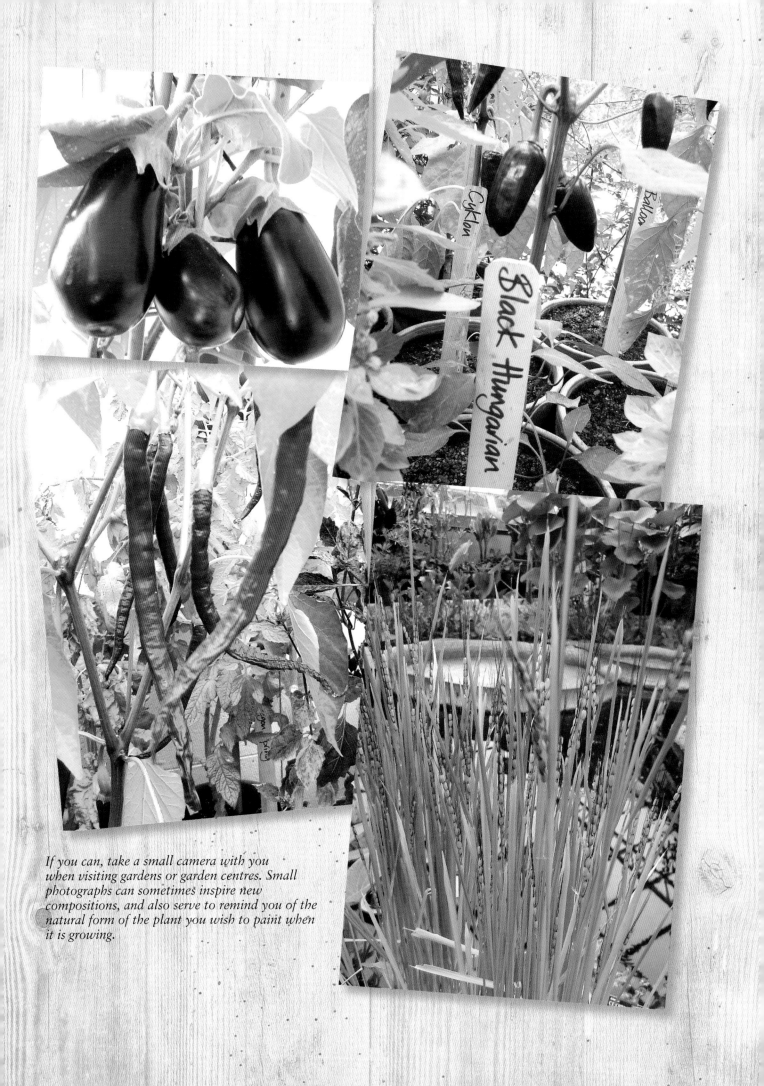

If you can, take a small camera with you
when visiting gardens or garden centres. Small
photographs can sometimes inspire new
compositions, and also serve to remind you of the
natural form of the plant you wish to paint when
it is growing.

I have included my pea paintings as a way of illustrating how you can play around with conventional views on composition, creating something that is both highly stylised and unique. I painted them with my boys in mind; one of them hated peas but loved beans, and the other loved peas and hated beans. This inspired me to produce numerous small paintings that celebrate little green vegetables.

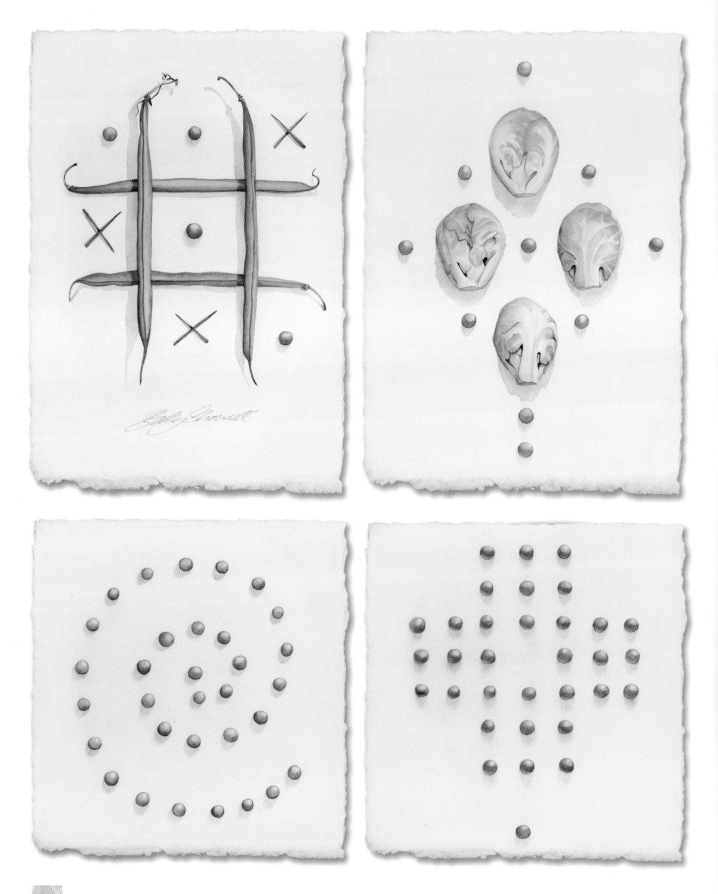

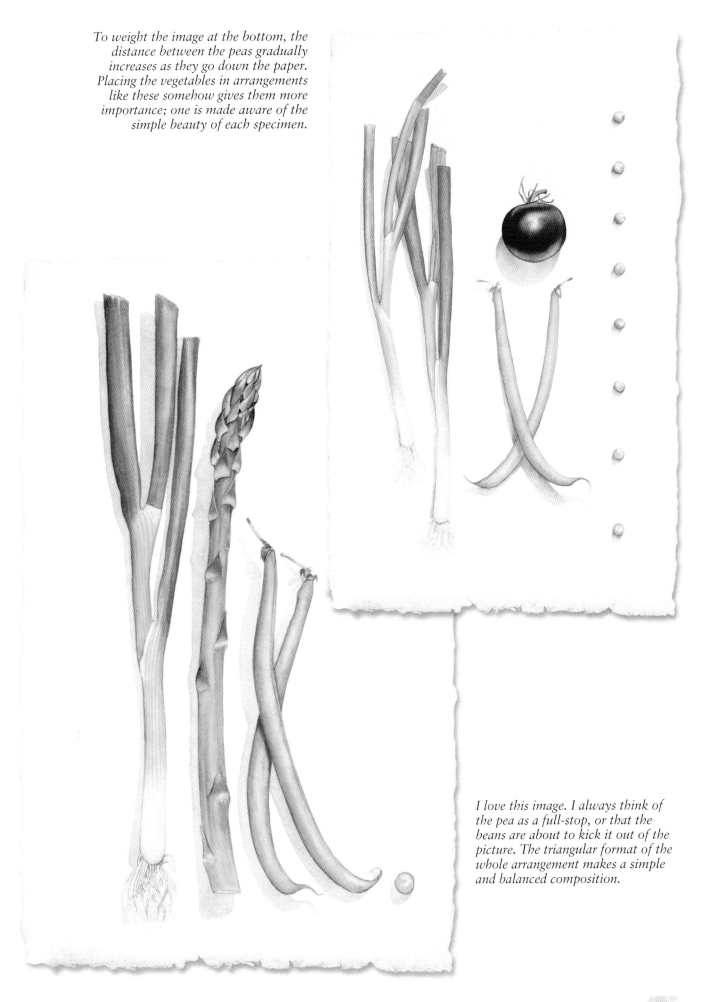

To *weight the image at the bottom, the
distance between the peas gradually
increases as they go down the paper.
Placing the vegetables in arrangements
like these somehow gives them more
importance; one is made aware of the
simple beauty of each specimen.*

*I love this image. I always think of
the pea as a full-stop, or that the
beans are about to kick it out of the
picture. The triangular format of the
whole arrangement makes a simple
and balanced composition.*

19

Tracing method

Occasionally I draw up a design first to get the composition correct and well balanced before transferring it to my watercolour paper. It can be a little laborious and time-consuming, and the tracing imprint is not always as sharp as a direct drawing on to the paper, but I have shown the process here as it is a good way of creating a composition, particularly for a beginner, and avoids over-use of the eraser!

Tip

Wash your hands after step 4 to avoid any accidental transfer of graphite from your hands to the clean paper.

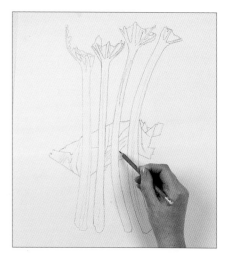

1. Begin by sketching out your finished design on a sheet of spare paper.

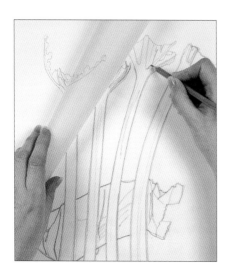

2. Lay a sheet of tracing paper over the top of the design and trace firmly over all the lines using an HB pencil.

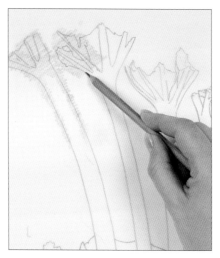

3. Turn the tracing over and gently rub pencil over the back of the design, making sure you cover all of the pencil lines.

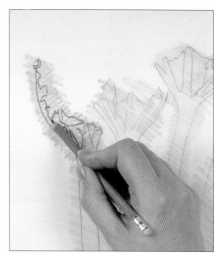

4. Turn the tracing right side up and place it on your watercolour paper, making sure the image is positioned correctly. Draw carefully over the design, pressing firmly with the pencil.

5. The image will be transferred to the watercolour paper, as shown above.

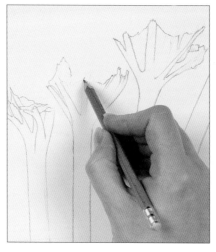

6. Remove the tracing paper and go over the outline on the watercolour paper to strengthen it if necessary.

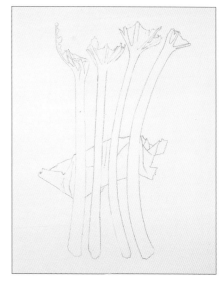

The finished drawing.

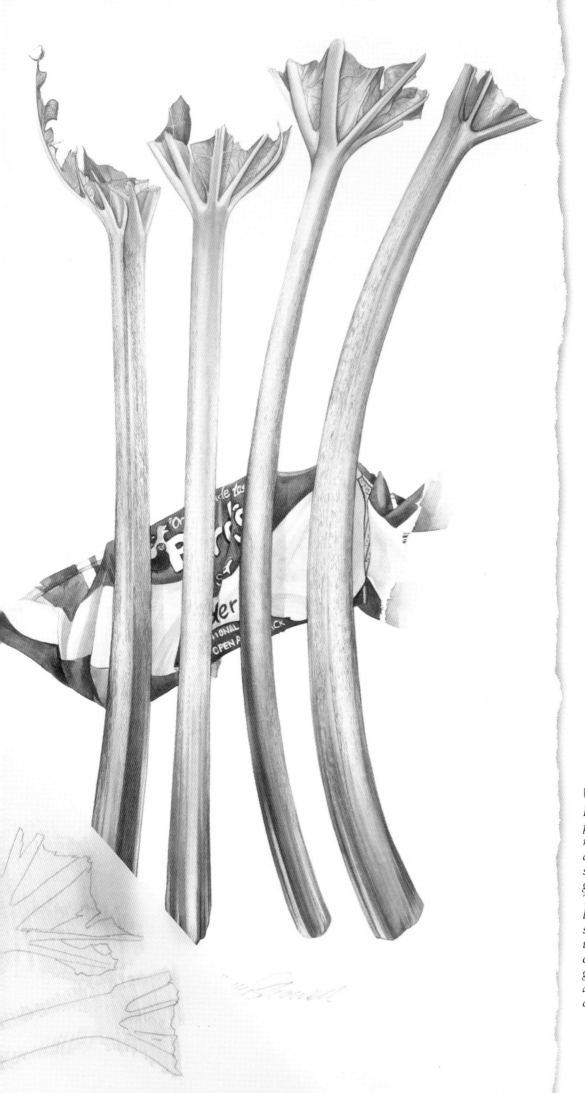

Rhubarb and Custard

*I painted this
picture to remind
myself of Sunday
dinners after a day
spent playing in the
garden as a child.
The strong vertical
lines of the rhubarb
stalks contrast
with the crumpled
custard packet to
give the composition
a quirky,
contemporary twist.*

Lighting

If you are working in the studio, lighting is extremely important as a means of defining form and shape. Make sure you light your paper as well as the subject of your painting. Light hitting an object will also surround the object, bounce off the surface it sits on and reflect back on to the object. All of these sources of light will have varying degrees of intensity, and by carefully observing them and reproducing their effects you will transform your painting from a flat representation of the subject to one with dimension and form.

I often add the cast shadow to a painting as many of my studies are without background colour and the shadow adds drama and interest (see page 49). Some people hold very strong views about the correct way to light a painting. I am not keen on rules in painting as I believe they inhibit creativity, but if your work is for a particular exhibition, society or medal, I suggest that you seek advice before painting a cast shadow on to the paper.

I usually shine the light from above left so as to illuminate the subject and not cast a shadow of my hand over the work (unless, of course, you are left-handed, in which case the light should be shone from the right). The light I use is a 50W halogen angle lamp – the light it produces is sharper than an average lamp and warmer than a daylight bulb, so it creates stronger, more painterly and visible shadows.

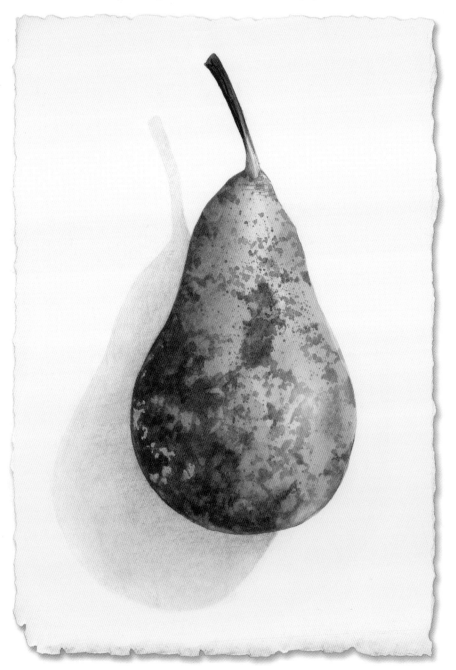

Observe and sketch out the shape of the shadow – it is often very different from the shape you think it should be.

I painted both this pear and the four apples on the page opposite with the light falling to the left to complement other paintings in the same collection.

22

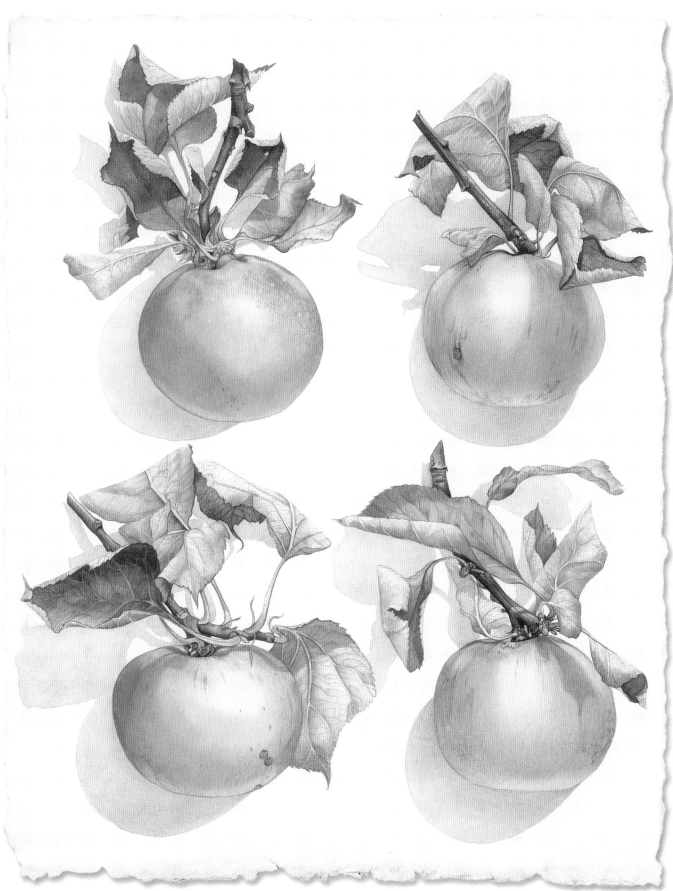

Four Bramley Apples
50 x 50cm (19¾ x 19¾in)

*The twisting, dancing forms of the leaves in this painting give the composition
a sense of movement that the apples on their own would otherwise lack.*

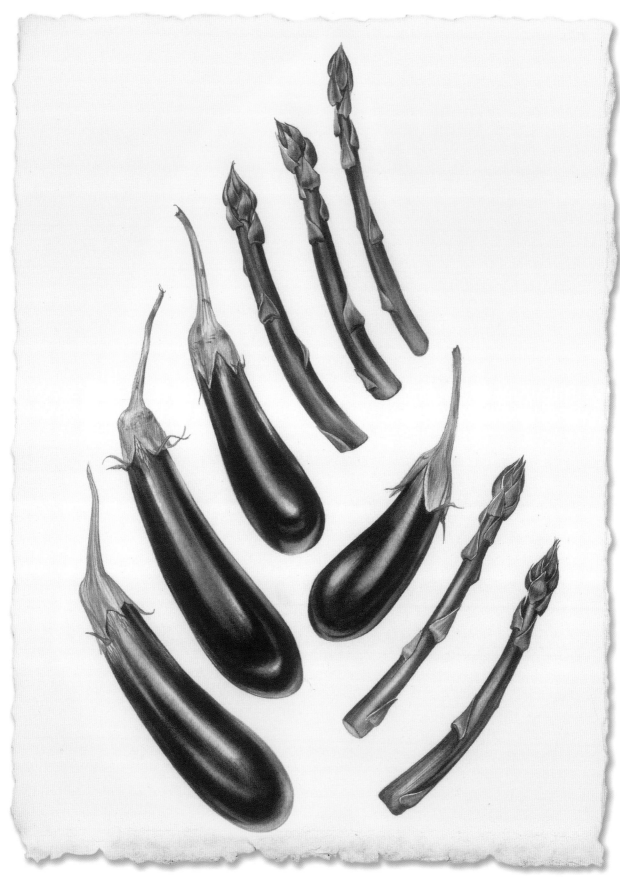

Aubergines (Eggplants) and Black Asparagus
24 x 35cm (9½ x 13¾in)

Once you have chosen the vegetables you wish to paint, lay them carefully on to some paper and place them in various arrangements to see which ones work. In this painting, I arranged the vegetables to reflect the shape of an aubergine (eggplant).

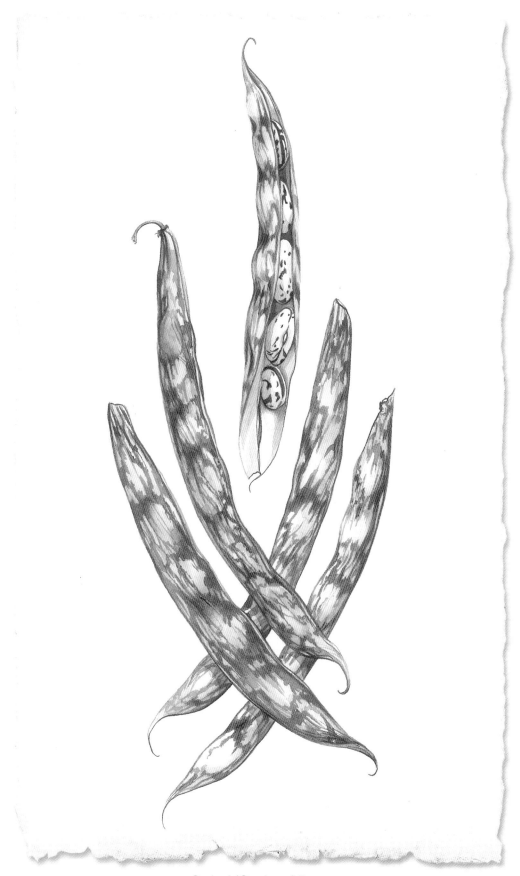

Borlotti (Cranberry) Beans
20 x 35cm (7¾ x 13¾in)

There are times when the subject of a painting is so eye-catching that it demands little in the way of composition. These beautiful, brightly coloured borlotti (cranberry) beans, for example, were simply gathered together in a pleasing arrangement to produce this striking painting.

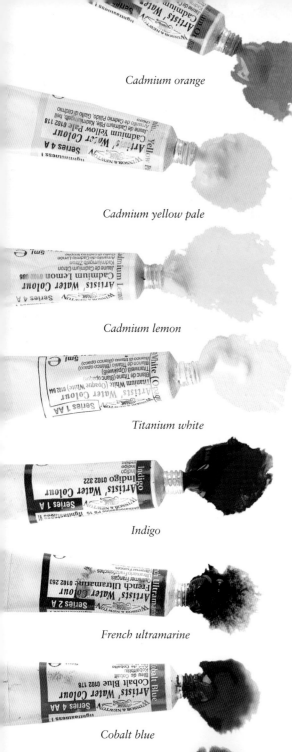

Cadmium orange

Cadmium yellow pale

Cadmium lemon

Titanium white

Indigo

French ultramarine

Cobalt blue

Quinacridone magenta

Quinacridone red

Ultramarine violet

Colour

I try to keep to a limited range of colours, but as I paint a lot of flowers as well as fruit and vegetables I do occasionally add a new tube of colour to my collection. You should not, however, feel restricted to my choices – try out new colours and modify your selection as you perfect your own palette. Your aim should be to build up a range of colours that consistently perform well, whose properties you can become familiar with, and that result in reliable colour mixes. It is best to start with a small range of high quality artists' quality paints, preferably a selection of primary colours (see the facing page). Additional colours can be bought every time you need to increase your range of mixes or a new, perhaps unusual colour is required. This avoids the cost of buying paints unnecessarily, and allows you to create an individual palette of colours that is tailored to the subjects you choose to paint.

The colours that are currently in my collection are shown around this page. The three most recent additions are opera rose, Winsor violet and Winsor blue (green shade). Opera rose is a fantastically vibrant pink; after trying it for the first time I embarked on what I can only describe as a 'pink period', as nearly all the subjects I chose to paint were pink, or had a hint of pink somewhere. Winsor blue (green shade) is an alternative to cerulean blue tone; it is just as fabulous for mixing greens, but seems to be more readily available in the shops. It has a wonderful bright aqua hue and its vibrancy is perfect for creating the juicy, bright greens that are perfect for young shoots and leaves.

Arranging your palette

I cannot stress enough the importance of arranging your colours in a familiar pattern on your palette. Many of the paints look similar when dry and this can lead to confusion; and if you put opposing colours too close together they may contaminate one another, resulting in muddy colour mixing.

My palette, showing the arrangement of colours around the perimeter. The space in the centre is used for mixing.

Colour mixing

There are a great many greens to mix when painting fruit and vegetables, and a huge variety of colours too, so understanding how to achieve successful colour mixes is essential. Information on paints and their properties can sometimes be a little overwhelming, but after much trial and error I have reduced it, mainly for my own understanding, to some simple key elements.

Primary colours

The primary colours, which every artist's palette should contain, are yellow, red and blue, and most other colours can be made from these. Because there seems to be no individual paint that is a true primary, I have two of each in my basic palette and mix them together: cadmium yellow pale is a warm yellow with a touch of red, while cadmium lemon is a cool yellow with a touch of blue, so a blend of the two results in a near-perfect primary yellow. Similarly, the two blues in my palette are French ultramarine (which is warm with a touch of red) and Winsor blue (green shade) (a cool blue with a touch of yellow); the reds are cadmium red deep (warm with a hint of yellow) and permanent rose (cool with a hint of blue); when mixed together, these appear to be a perfect primary red.

Cadmium red deep

Opera rose

Winsor violet

Winsor blue (green shade)

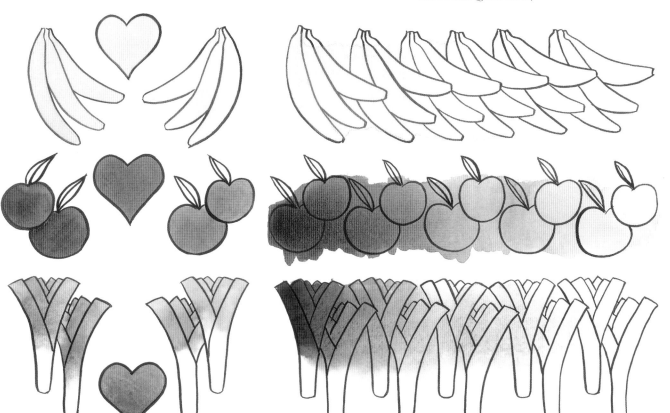

The left-hand pictures above show the two examples of each primary colour I have in my basic palette; from top to bottom and from left to right they are cadmium yellow pale and cadmium lemon, cadmium red deep and permanent rose, and French ultramarine and Winsor blue (green shade). The hearts show the colour I obtain by mixing the two together. On the right are pictures showing how you can reduce the tone of a colour (its relative lightness or darkness) by adding progressively more water to the mix; the more water you add, the lighter the tone.

Permanent rose

Alizarin crimson

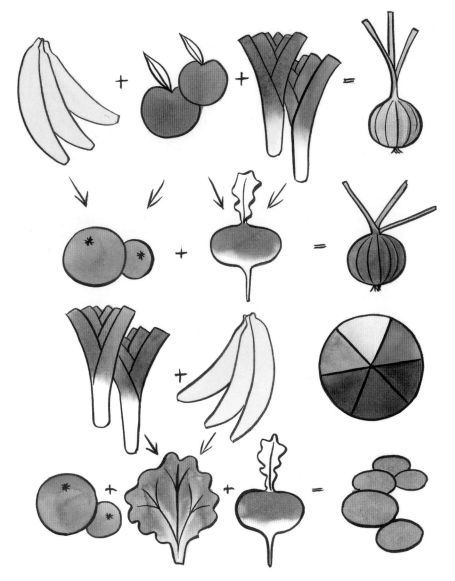

Secondary colours

Combining two primaries results in the creation of a secondary colour, for example mix yellow and blue to make green, red and blue to achieve purple and red and yellow to make orange. Different quantities of either of the primary colours will result in a different shade of the secondary colour, thus different amounts of red and yellow result in a multitude of oranges. Each of these orange mixes in turn has a full range of tones, from the darkest, most concentrated version to the palest (achieved by the gradual addition of water).

Tertiary colours

Mix three primary colours together and the result is a tertiary colour. Tertiary colours tend to be 'earthier' colours – greys and browns. There is a seemingly endless variety of colours you can create simply by mixing the three primaries (see the range of browns on page 31). When I am in the mood to experiment, I 'doodle' with my paints and try to create as many variations of one colour mix as possible. Try this yourself; it's addictive, and a fantastic way of practising colour mixing.

This chart shows just one mix at each stage. There are countless variations of colour intensity and density of pigment, but it will give you a method to follow if you are at the beginning of your colour mixing journey.

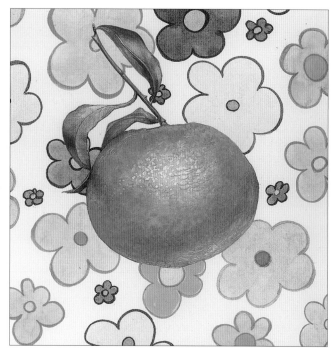

A colourful napkin provided the inspiration for this pretty background. Citrus fruits, like this tangerine, have such intense colour, it is fun to introduce other bright colours to the study.

Mixing browns

As with most of my colour mixing, all of the browns I use are created from my basic primary palette. I find that the shades I create myself feel closer to natural browns than pre-mixed varieties. Also, it means that all of the browns I use are related to all the other colours in my paintings, bestowing them with a sense of unity and cohesion. The exceptions to this are any subjects in which unusual colours predominate, such as pinks or purples; in this case I would add yellows to the pinks to create a range of browns with a common link.

It is very rewarding to create such an array of beautiful colours and variations in shade and tone: the range is almost inexhaustible. All the browns pictured below are created from various mixes of French ultramarine, cadmium yellow pale and cadmium red deep.

Combine various quantities of each primary colour to create a range of tertiaries, with varying degrees of tone produced by adding more or less water.

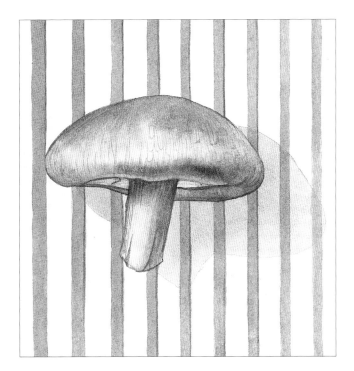

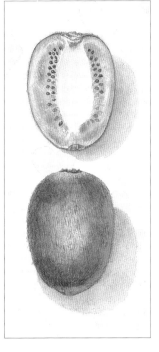

The humble mushroom and the kiwi fruit require a huge array of browns to reproduce their subtle tones. The kiwi fruit has a soft green-brown background with darker washes layered on top, and tiny hairs dry brushed on using the tip of a fine paintbrush (see page 42). Both subjects are enhanced by placing them on a contrasting background, reminiscent of the colourful paper bags once used by traditional greengrocers.

Dark washes

Getting the correct depth of colour wash is very important; so often, colours fade or change as they dry. You can compensate for this by increasing the quantity of paint in the mix. This is quicker with tube paints, as it is easier to get a larger amount of pigment into the wash and on to the paper in fewer washes. This requires a little bit of practice as the wash can become too thick and result in a heavy matt finish.

Yellow is a particularly tricky colour to get right as sometimes it can appear very accurate when wet but then dry to leave an insignificant amount of colour; using too much yellow can make the subject seem artificial. Avoid disappointment by trying out the colour on scrap paper first.

Really deep shades, like those required for the pear stems below, can be achieved on the second glaze of colour by mixing indigo with cadmium red deep and a touch of cadmium yellow pale, but be wary of using this mix as your first wash, as the indigo will stain the paper blue, thus making it impossible to lift out any highlights.

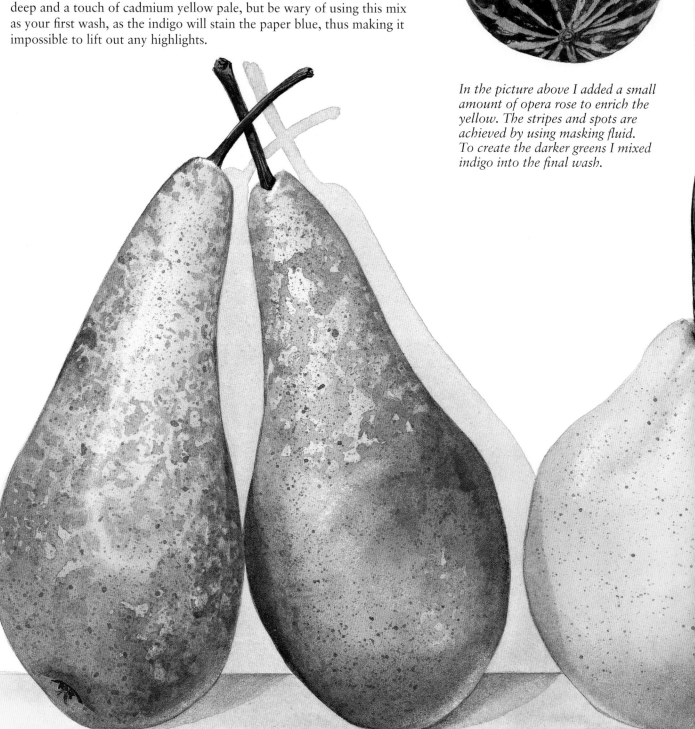

In the picture above I added a small amount of opera rose to enrich the yellow. The stripes and spots are achieved by using masking fluid. To create the darker greens I mixed indigo into the final wash.

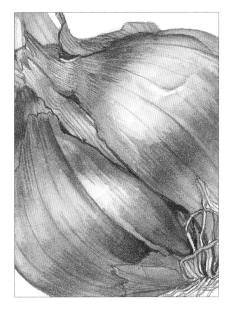

This richly coloured onion requires a broad range of intensely warm browns to do it justice.

Ginger demands softer, pinky browns, mixed from the three primaries with a hint of opera rose.

Soft golden browns were required for the dry foliage of the sweetcorn. Dark brown spots were dropped into the glaze to create mildew.

The Line-up
50 x 40cm (19¾ x 15¾in)

This painting is one of my most popular prints. The pear in the centre is a Chinese pear, which is a beautiful, soft, creamy, golden colour. I like this composition as it conjures up an image of a fruit identity parade.

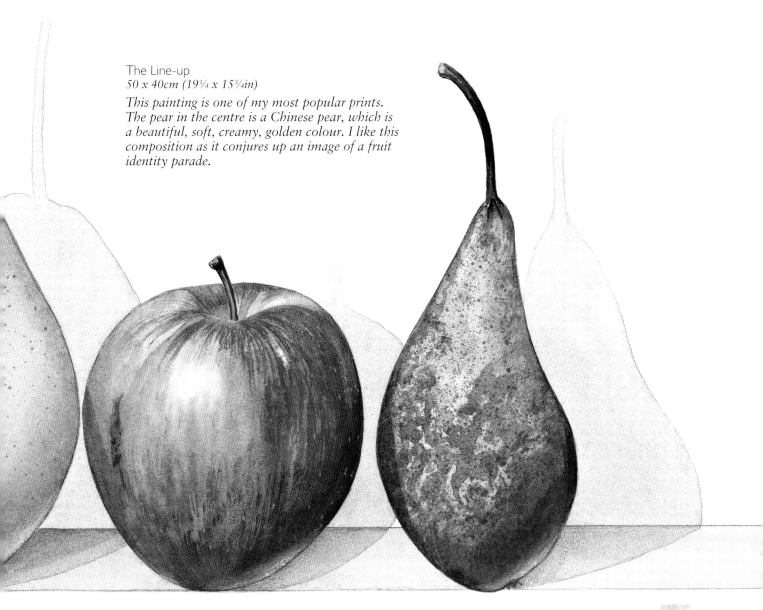

Mixing greens

I love painting with green – there are so many subtle shades and nuances. Different mixes of the same colours can portray a subject as dry, waxy, fresh or crisp. I use a very limited palette for mixing greens. This is not to say that using other colours would be wrong, but by using just a few primary colours the palette remains simple and the picture is held together by a unifying colour theme.

The best way to become good at mixing greens is to practise. Start by discovering how many shades of green you can mix from one blue and one yellow. Vary the depth of the colour by adding water and then, once you have exhausted all the possibilities, start the mixing process again, adding one more colour to the mix. Observe how the mixes dry and then see what effect is achieved by laying a thinner glaze of colour over the top. Continue experimenting, making a note of what colours you used to create each series of greens so that you have the information to hand for future reference.

I mix most of my greens from the following colours: French ultramarine, Winsor blue (green shade), cadmium yellow pale, cadmium lemon, cadmium red deep and indigo. I use the red and the indigo as additional aids to achieving darker or earthier greens.

The picture above shows a few of the greens that can be mixed from just six colours. I started with French ultramarine and cadmium yellow pale to produce the three greens shown in the top row of the chart; the left-hand column has had more French ultramarine added to it and that on the right has more cadmium yellow pale. To the subsequent rows I added (working from top to bottom) cadmium lemon, Winsor blue (green shade), cadmium red deep and indigo.

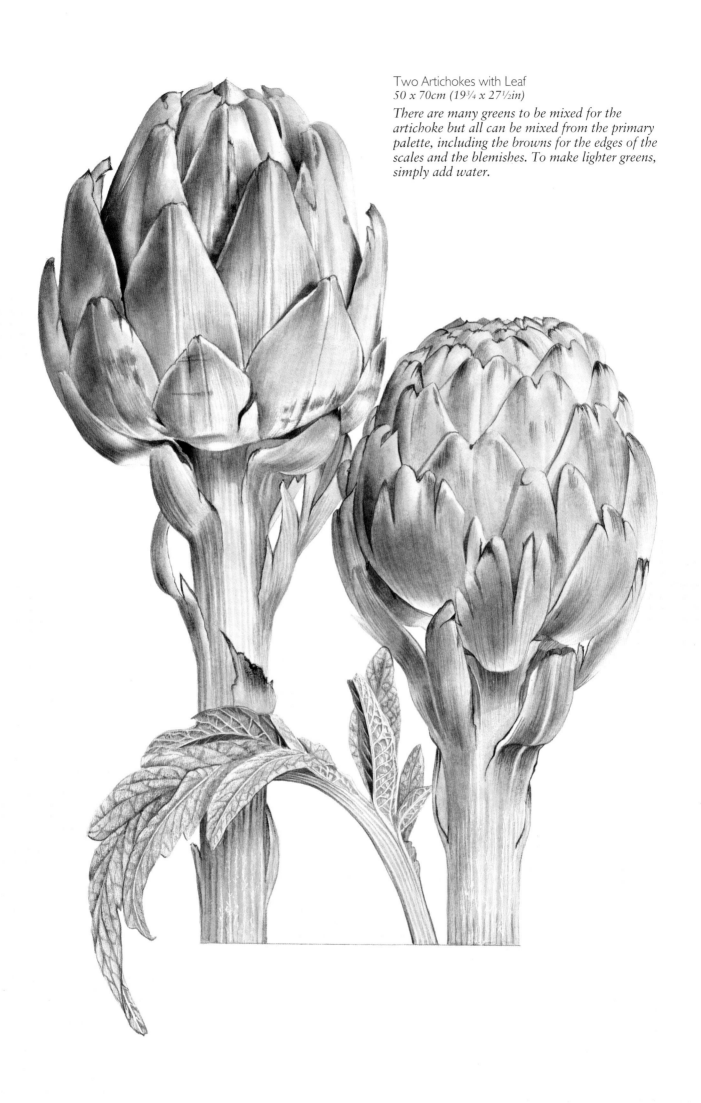

Two Artichokes with Leaf
50 x 70cm (19¾ x 27½in)

There are many greens to be mixed for the artichoke but all can be mixed from the primary palette, including the browns for the edges of the scales and the blemishes. To make lighter greens, simply add water.

Mixing colours

There seems just as much variety of colours in painting fruit and vegetables as there is in painting flowers. Your mixes will need to be bold and fresh and your palette kept clean to ensure bright, edible-looking and appealing colours.

Fruit and vegetable painting requires you to master deep washes of colour; there is little need for transparent washes, and fruit and vegetable portraits tend to have more substance than flower paintings. Reflected light plays an important part in creating volume and is often a subtle shade of an adjacent colour, therefore requiring careful observation.

The pictures below show sections of different fruit and vegetables and the colours I used to paint them. Use them as a reference and starting point for your own paintings. Experiment on how deep your washes can go before becoming too heavy and enjoy the process of colour mixing. Remember to keep your mixes simple: less is more.

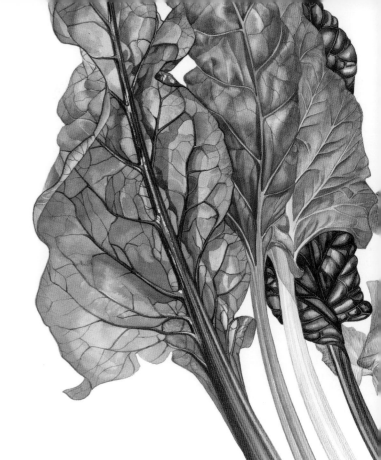

The multi-coloured rainbow chard is not only fun to grow and good to eat, it also makes a wonderful subject for a painting. Strong lighting helps to define the texture, creating a dramatic effect.

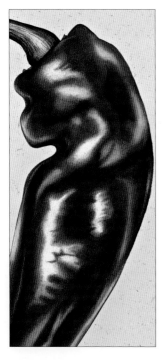

Red pepper

Cadmium red deep, quinacridone red, permanent rose, alizarin crimson and French ultramarine.

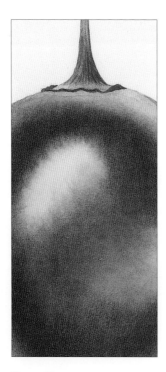

Tamarillo

Cadmium orange, cadmium red deep, alizarin crimson, quinacridone red, permanent rose, cadmium lemon and a touch of French ultramarine.

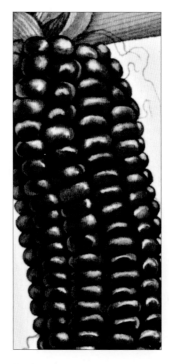

Red corn

As for the tamarillo, but with additional cadmium red deep mixed with indigo.

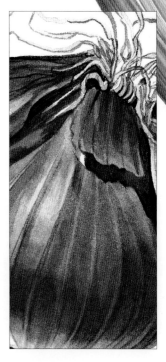

Red onion

Permanent rose, quinacridone red and French ultramarine.

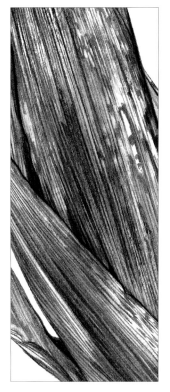

Corn husk

Cadmium red deep, French ultramarine and mauve.

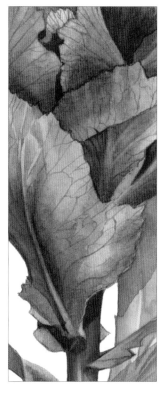

Ornamental cabbage

Cobalt blue, mauve and permanent rose.

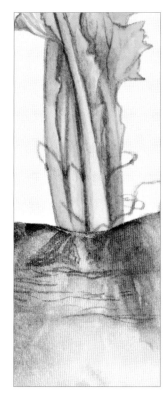

Turnip

Quinacridone red, permanent rose and cobalt blue.

Spring onions

Quinacridone magenta and permanent rose.

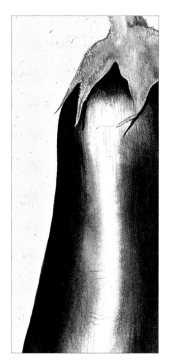

Aubergine (eggplant)

The first layer is French ultramarine, cadmium red deep and cadmium yellow pale. Further glazes are of indigo mixed with cadmium yellow pale and cadmium red deep.

Black tomato

Alizarin crimson, French ultramarine and cadmium yellow pale.

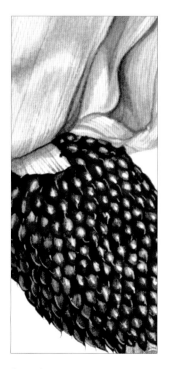

Strawberry popcorn

Alizarin crimson, French ultramarine, cadmium yellow pale, permanent rose and cadmium red deep.

Beetroot (beet) leaf

French ultramarine, cadmium yellow pale and permanent rose.

35

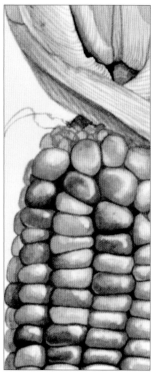

Yellow corn

Cadmium yellow pale, cadmium lemon, cadmium red and a small touch of cobalt blue.

Pineapple

Cadmium yellow pale, permanent rose and cadmium orange.

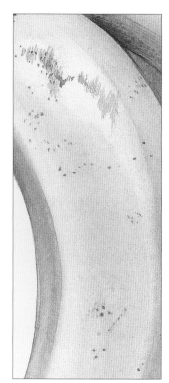

Banana

Cadmium lemon, cadmium yellow pale, cobalt blue and cadmium red deep.

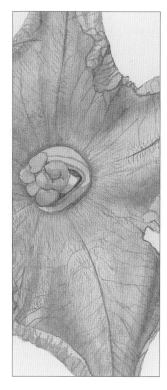

Courgette (zucchini) flower

Cadmium orange, cadmium lemon, cadmium yellow pale and Winsor blue (green shade).

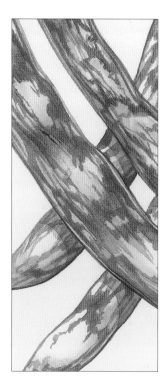

Borlotti (cranberry) beans

Permanent rose, opera rose and French ultramarine.

Rhubarb

Permanent rose, cadmium yellow pale and Winsor blue (green shade).

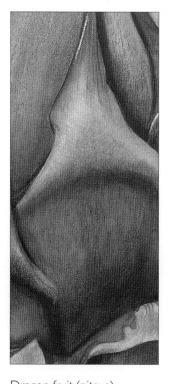

Dragon fruit (pitaya)

Permanent rose, opera rose, French ultramarine, cadmium yellow pale and quinacridone red.

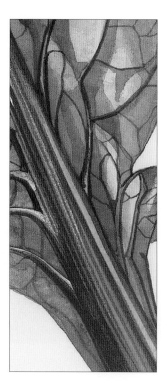

Rainbow chard

Permanent rose, opera rose, French ultramarine, cadmium yellow pale, quinacridone red and cadmium red deep.

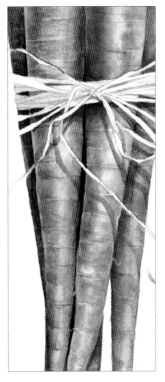

Carrots

Cadmium orange, permanent rose and cadmium red deep.

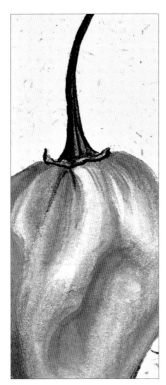

Pepper

Cadmium orange, permanent rose, cadmium red deep and cadmium lemon.

Onion

Cadmium yellow pale, cadmium red deep and permanent rose.

Tangerine

Cadmium orange, cadmium yellow pale, cadmium red deep and permanent rose.

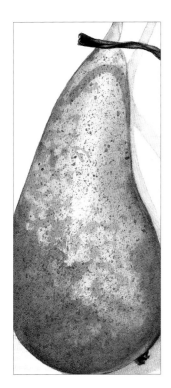

Pear

Cadmium lemon, French ultramarine, cadmium yellow pale, cobalt blue and cadmium red deep.

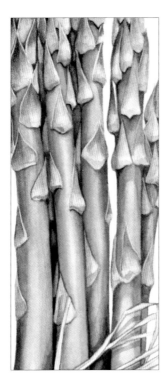

Asparagus

Winsor blue (green shade), cadmium yellow pale, cadmium lemon and French ultramarine.

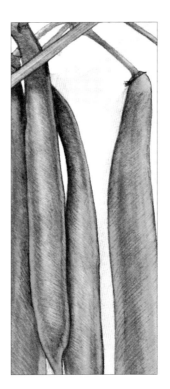

Runner beans

Winsor blue (green shade), cadmium yellow pale, cadmium lemon and French ultramarine.

French (green) beans

French ultramarine, cadmium yellow pale and cadmium red deep.

Techniques

In this section I will cover the main watercolour techniques that I use. Practice is the secret to confident watercolour painting, so it is a good idea to try all the techniques explained here before embarking on the projects. Repeating techniques many times over is a valuable exercise, and it is helpful to have experienced just how quickly glazes of colour dry before embarking on a painting. Watercolour paper is expensive, so practice the techniques in a sketchbook, or on scraps of paper or abandoned paintings.

Try not to rush, and avoid over-working the colour once you have applied it to the paper. For the best results, drag the paint using just two or three brushstrokes and then allow it to spread, settle and dry naturally.

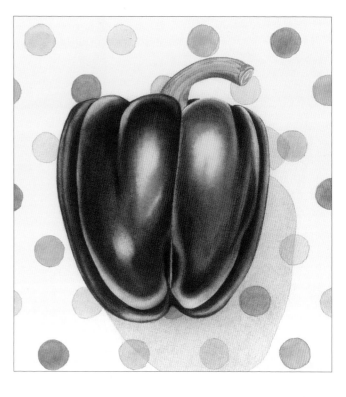

This unusual pepper has a wonderful deep mauve colour. The strong highlights were created by leaving the paper free of paint when applying the first mix.

Wet-into-wet

This is a technique that it is essential to master in order to achieve speed, and to give a sense of softness to a painting. It is also helpful in the depiction of natural light. I begin all my paintings using this technique, as it results in the paint spreading naturally across the paper rather than soaking straight in, thus avoiding hard edges. It also means that two or three different colours can be applied separately, one after the other, and allowed to mix and blend on the paper before they dry.

1. Begin by glazing the area you are painting with clean water. While it is still wet, drop in a watery mix of colour. The paint will spread naturally on the paper, so add the colour where it is most intense and allow it to feed down to where you wish it to fade out.

2. Smooth the paint out towards the base of the fruit using a clean, damp paintbrush, softening the edges of the colour and avoiding any highlights (this should only be done while the glaze is wet; if you disturb the paint while it is drying you will create a messy finish).

Tip
Only lift out the highlights or soften the edges of the colour wash with a damp brush. If the brush is wet, it will deposit water on to the settling colour and push the colour to the edge of the wash leaving a dark outline. If this has never been explained to you before, then you will find this one piece of advice extremely valuable.

Colour blending

Colour can be blended on the paper by applying further glazes of colour once the first glaze is dry.

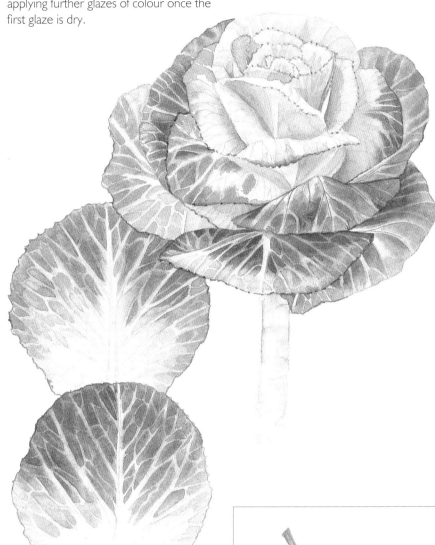

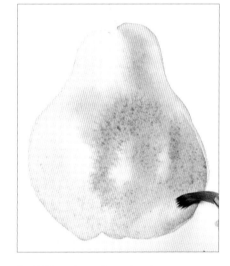

1. Allow the first layer of paint to dry thoroughly. Glaze the area with clean water and drop in the next colours, allowing them to blend on the paper.

The wet-into-wet technique is the perfect way of achieving the subtle colour variations exhibited by the ornamental cabbage. The colours are built up gently by blending, and the veins defined once the final layer has dried.

2. With a clean, damp brush, use sweeping movements to blend the colours together, remove hard edges and lift out any highlights.

3. Allow the paint to dry. This study is now ready for the addition of detail and shadow.

Lifting out colour

This is a technique that results in soft highlights, often slightly coloured by a little of the wet colour glaze. Demonstrated here, on a small aubergine (eggplant), is the difference between leaving the paper clear for the strong highlights and lifting out the colour for the softer reflected light underneath.

Some colours are quick to stain the paper and so are not suitable for lifting, so be wary. The main colours to avoid in my experience are any with the word 'permanent' in the title and indigo.

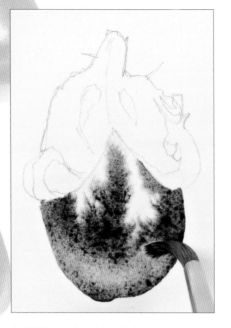

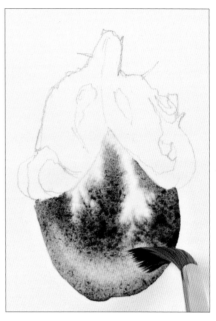

1. Make a mix of the darkest colour, in this case using cadmium red, French ultramarine and a touch of cadmium yellow pale. Lay a clear glaze first, then lay in the colour around the highlights. While the paint is still wet, lift out the reflected light in a single stroke using a clean, damp brush.

2. Working quickly, before the paint begins to dry, lift out the reflected light a second time using a clean, damp brush. You need to remove as much of the colour as you can.

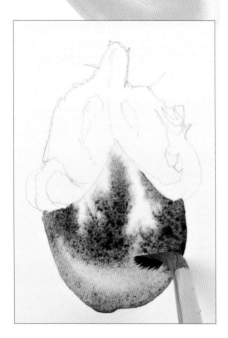

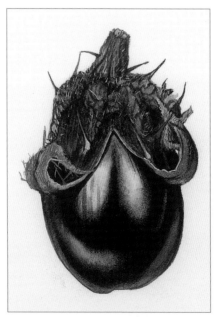

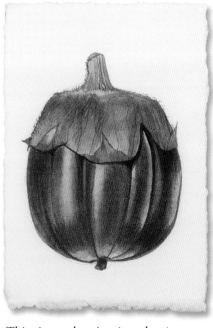

3. Lift out the reflected light for a third time. By now you should be getting close in colour to the highlights. You can continue lifting out colour all the time the paint is wet, but as soon as it begins to dry, stop.

Using the techniques of wet-into-wet, lifting out, colour blending and strengthening, the aubergine gathered weight and form. The finished painting shows clearly the difference between the lifted-out highlights and those created by leaving the paper clear of paint.

This tiny aubergine (eggplant) required me to work speedily to lift out all the highlights.

Using lifting preparation

Lifting preparation is a liquid that you paint on to the paper and allow to dry before you start to paint. You can then paint over the top of it and then lift out the colour completely. It is very useful when you are using strong or staining colours but want to lift out bright highlights. I discovered this product by chance and have found it extremely useful for areas where small, bright highlights are required, but I am still experimenting with larger, more dramatic uses.

Apply a generous coating of lifting preparation over the drawing. Allow to dry.

Glaze with water and drop in colour. Allow to dry.

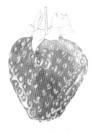

Lift out highlights with a wet brush and paper towel. Allow to dry.

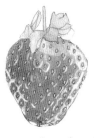

Deepen the colour by using smaller, drier mixes. Allow to dry.

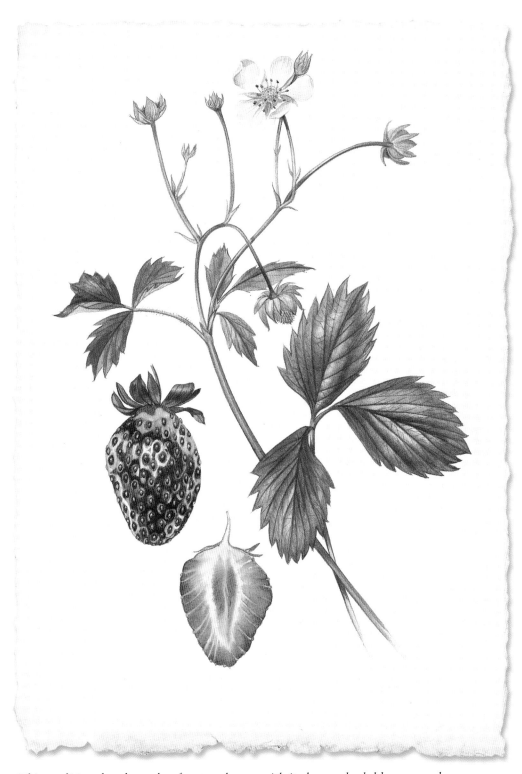

This traditional-style study of a strawberry, with its leaves, bud, blossom and cross-section, required much detailed work and careful composition.

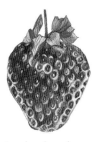

Use the dry-brush method to add the deepest reds.

41

Glazing over shadows

This method, demonstrated here using a pale green aubergine (eggplant), is used for lighter, fresher colours where the shadows could sometimes interfere with the delicate colour of the object (see the lemon on pages 106 to 116).

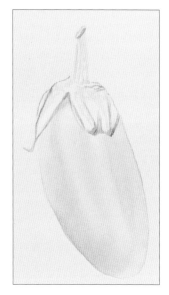 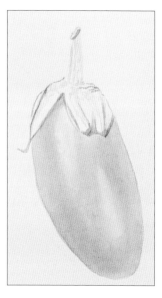

1. Lay on the shadows using various shades of the mid-tone mix (see page 48). Allow the paint to dry.

2. Make a very pale green mix of Winsor blue (green shade) and cadmium lemon. Glaze with water and drop in the green, avoiding the highlight.

3. Lift out the reflected light.

4. Lay on a stronger green while the paint is still wet and blend it in.

Dry brushing

Dry brushing can be used to add detail, texture or patterning to a painting. Here I have used it to add hairs to a kiwi fruit.

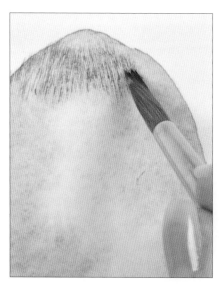 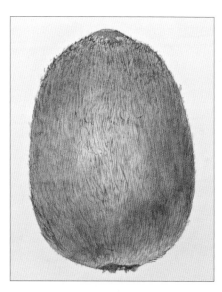

1. Begin by picking up the paint and removing the excess by dabbing the brush on a roll of kitchen paper or a piece of cotton cloth. As you do so, spread out the hairs of the brush. If the hairs on your brush do not separate, try very gently flattening the damp brush between your fingertips and then picking up the colour from the edge of the puddle of paint.

2. Dab the paint on to a dry surface, which has already had the background colour applied. Use small strokes of the brush, all laid in the same direction, to resemble the short hairs covering the surface of the fruit.

3. Continue to cover the surface of the kiwi, placing the brushstrokes in the same direction as the hairs. Finish by laying over a light glaze of the mid-tone colour (see page 48) for the shadows.

Scratching out

This is a process that should only be done at the end of a painting as it damages the surface of the paper. Use a sharp scalpel to gently flick out a small highlight. The beauty of this, if done well, is that it reveals a small area of pure white paper, which shines out to create the illusion of bright light on a shiny surface.

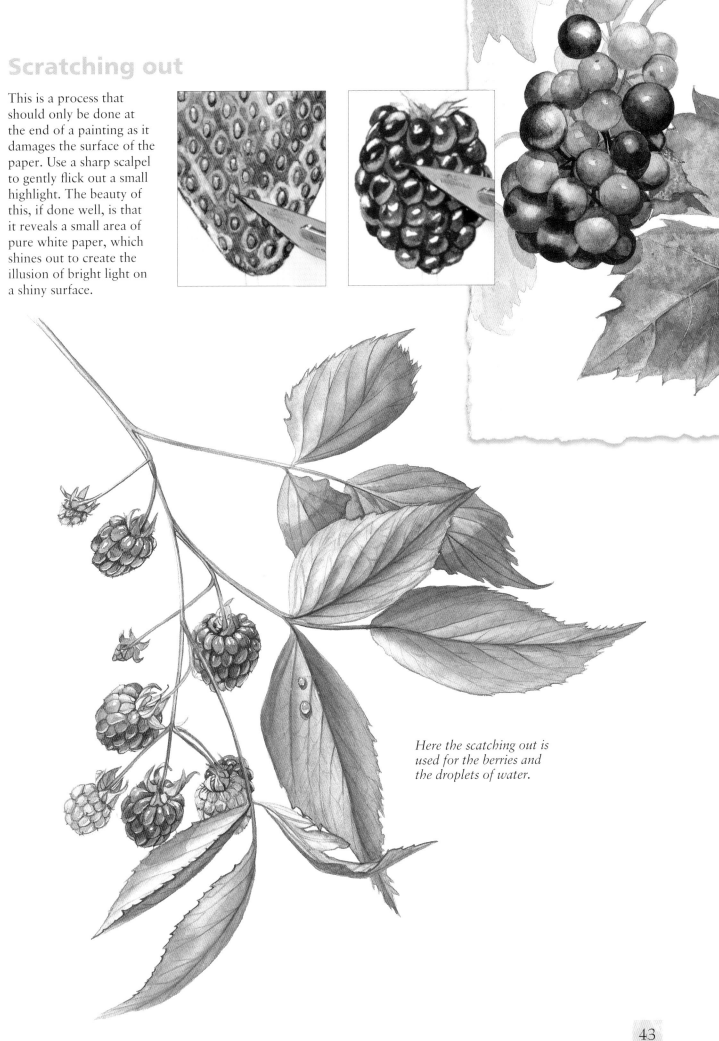

Here the scatching out is used for the berries and the droplets of water.

Using masking fluid

I use masking fluid only when really necessary as I find that sometimes the sharp edges can create a rather flat result. Here, in the painting of a red chilli (chili pepper), I have lifted the colour from around the masking fluid; this allowed me to graduate the paint into the highlight, avoiding a flat sharp edge. The most common use for masking fluid is to protect an area while you paint over it. Once the paint is dry, it is rubbed away to reveal the white paper underneath, which can be kept or painted upon itself.

Tip
Always wet the brush first before dipping it into the masking fluid and wash the brush until it is thoroughly clean in between applications (about every ten seconds or so). This will prolong the life of your brush and allow for cleaner applications. Always use a synthetic brush.

Tip
Do not attempt to remove the masking fluid until the painting is completely dry.

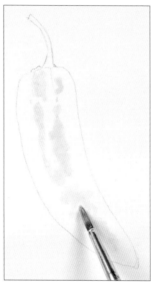

1. Using an old paintbrush, paint in the brightest highlights with masking fluid. Allow it to dry completely.

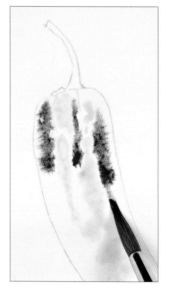

2. Glaze over the chilli with clear water and drop in the colour. Allow it to bleed up to the edge of the masking fluid.

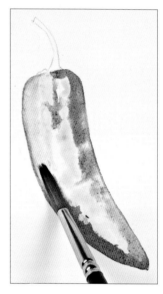

3. Lift out the reflected light.

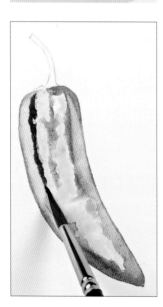

4. Drop in more colour around the masking fluid and allow the paint to dry.

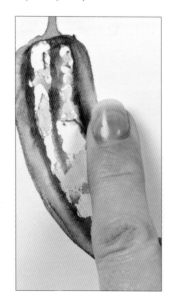

5. Use your finger to rub off the masking fluid.

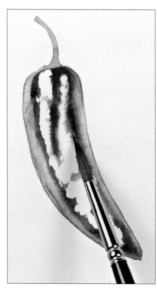

6. Lay a clear water glaze over the whole area to soften the edges around the masking fluid.

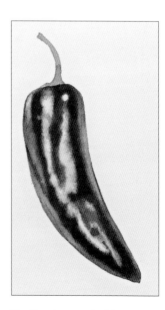

7. Continue to build up the colour using the dry-brush method to complete the painting.

Vegetable Pyramid
30 x 40cm (11¾ x 15¾in)

There are various ways of creating areas of reflected light and highlights that give a softer finish than masking fluid, as exemplified by these colourful fruit and vegetables; these techniques are explained elsewhere in the book (see pages 48 to 51). The textured background on this colourful image was added digitally.

Strengthening colour

I have wanted to paint a tamarillo for a long time; they are glossy and smooth, with an intense combination of reds that requires several glazes to achieve the correct depth of colour. I had never tasted a tamarillo before this demonstration, and the flavour is wonderfully reminiscent of perfect summer days in the garden.

1. Begin by laying on a glaze of clean water just within the pencil outline.

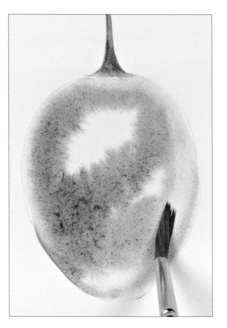

2. Lay on the first wash of colour, avoiding the highlights, and allow it to dry, then remove the pencil outline.

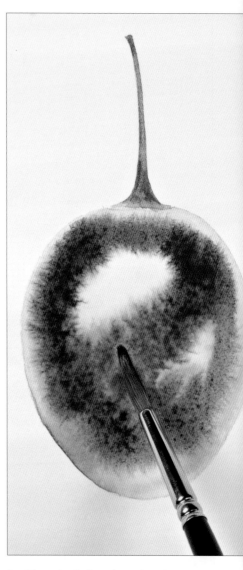

3. Glaze the fruit again and apply a second layer of paint. Use a slightly stronger mix of the first colour and, if you wish, introduce a second colour. Allow the two colours to blend on the paper, then leave to dry completely.

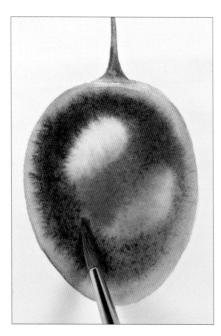

4. Apply a third glaze – clean water first, then a brighter, more jewel-like mix of the first colour. Add a little of the second colour as well, and smooth out the paint using a clean, damp brush.

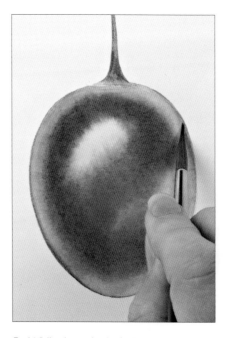

5. While the paint is drying, tidy up the edges of the fruit using the tip of the brush. Do this by moving the paint that is already on the paper, and avoid creating an outline. Allow the paint to dry.

6. Make a thicker mix of paint, adding some blues and yellows to the red to make it darker and warmer. Without glazing with water first, use the dry-brushing technique to build up the colour on the darkest areas. Move the brush using circular movements so that the brushstrokes do not all lie in the same direction.

7. Use different colours if necessary as you move round the fruit, blending them carefully. Allow the paint to dry.

8. Gently glaze over the entire area with a damp brush to pull everything together and smooth out the brush marks. Soften the edges of the highlights. Allow to dry.

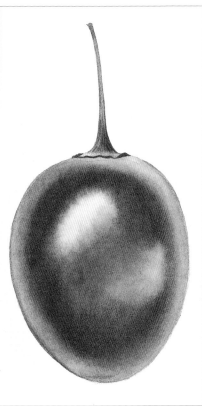

9. Add a light, lemony wash to the whole painting to warm it up.

The softness and richness of the final colours was achieved by building up the paint gradually, layer upon layer.

Light and shade

To create dimension in your fruit or vegetable portraits, take time to observe the light falling on the subject. Highlights are the strongest areas of light, created by light falling directly on to the surface from the main light source. Reflected light is the light bouncing off another surface and reflecting back on to the subject, for example from the table top or drawing board, or from other fruit or vegetables close by. Reflected light is usually paler and more diffuse than direct light. Shadows, too, often contain local colour from the surrounding objects.

Highlights

The best way to achieve bright highlights is to use the white of the paper. To give the highlights soft edges, glaze the subject with clean water and lay the colour around the highlights, allowing extra space for the paint to spread. Wash your brush thoroughly and remove excess water from it, then be ready to lift out any spreading paint that threatens to conceal the white paper highlight.

Shadows

Adding shadows to your study is not always needed, but if you do choose to include them follow the three simple steps below using a shadow mix similar to those shown at the bottom of the page.

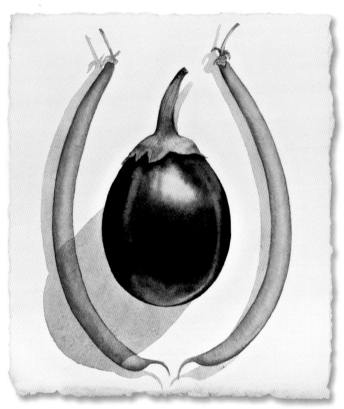

On this baby aubergine (eggplant) the main source of light was a window above, resulting in dramatic shadows. The reflected light was from the table.

1. Lightly draw the shape of the shadow.

2. Glaze the shape precisely with water then lay in the mid-tone shadow mix carefully from top to bottom without going back over the glaze.

3. To deepen the shadow, lay on another water glaze and repeat step 2.

Shadow mixes

My main shadow mix, which I call the 'mid-tone', is created with two parts French ultramarine, one part cadmium yellow pale and one part cadmium red deep. I then add a small amount of colour from the subject to give it warmth and reality. From 1 to 4, these are cadmium lemon, alizarin crimson, opera rose and quinacridone magenta.

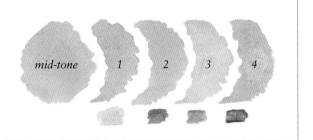

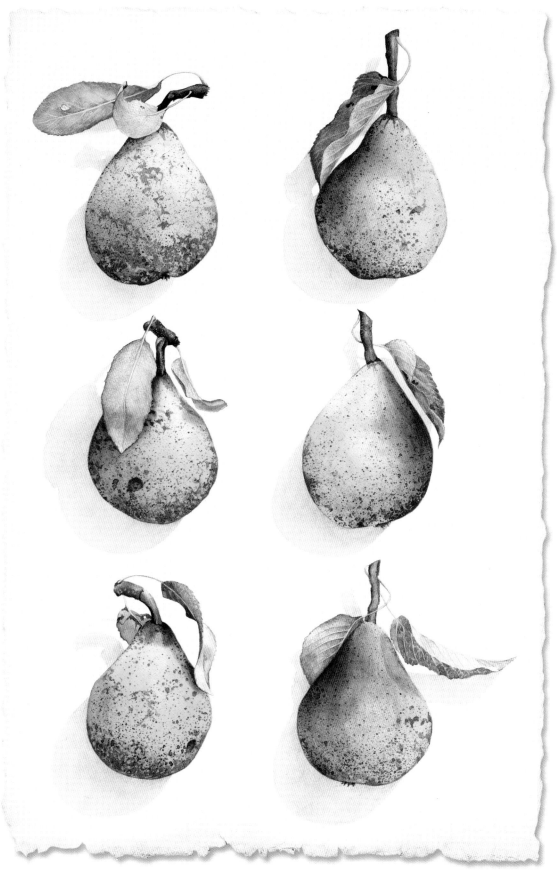

Six Pears
50 x 70cm (19¾ x 27½in)

These pears were bright blue-green and not yet fully ripe when I painted them. The detail was added after the form had been achieved with washes of colour. The highlights were not strong so I painted in the shadows to 'push' the pears off the page.

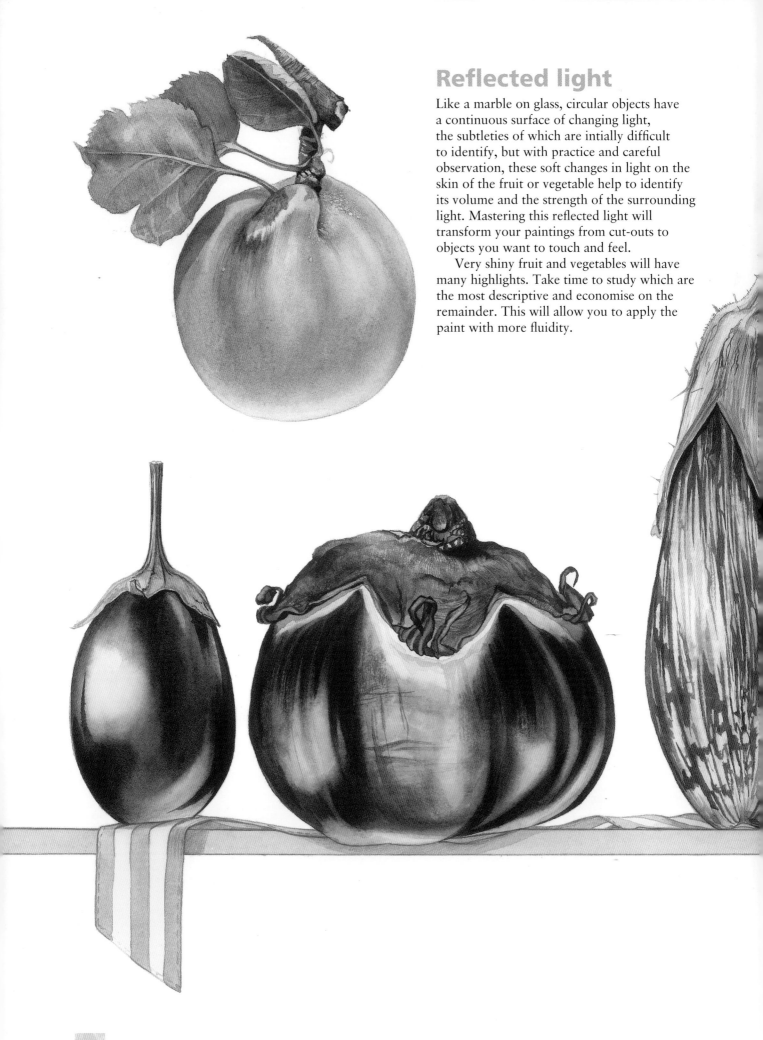

Reflected light

Like a marble on glass, circular objects have a continuous surface of changing light, the subtleties of which are intially difficult to identify, but with practice and careful observation, these soft changes in light on the skin of the fruit or vegetable help to identify its volume and the strength of the surrounding light. Mastering this reflected light will transform your paintings from cut-outs to objects you want to touch and feel.

Very shiny fruit and vegetables will have many highlights. Take time to study which are the most descriptive and economise on the remainder. This will allow you to apply the paint with more fluidity.

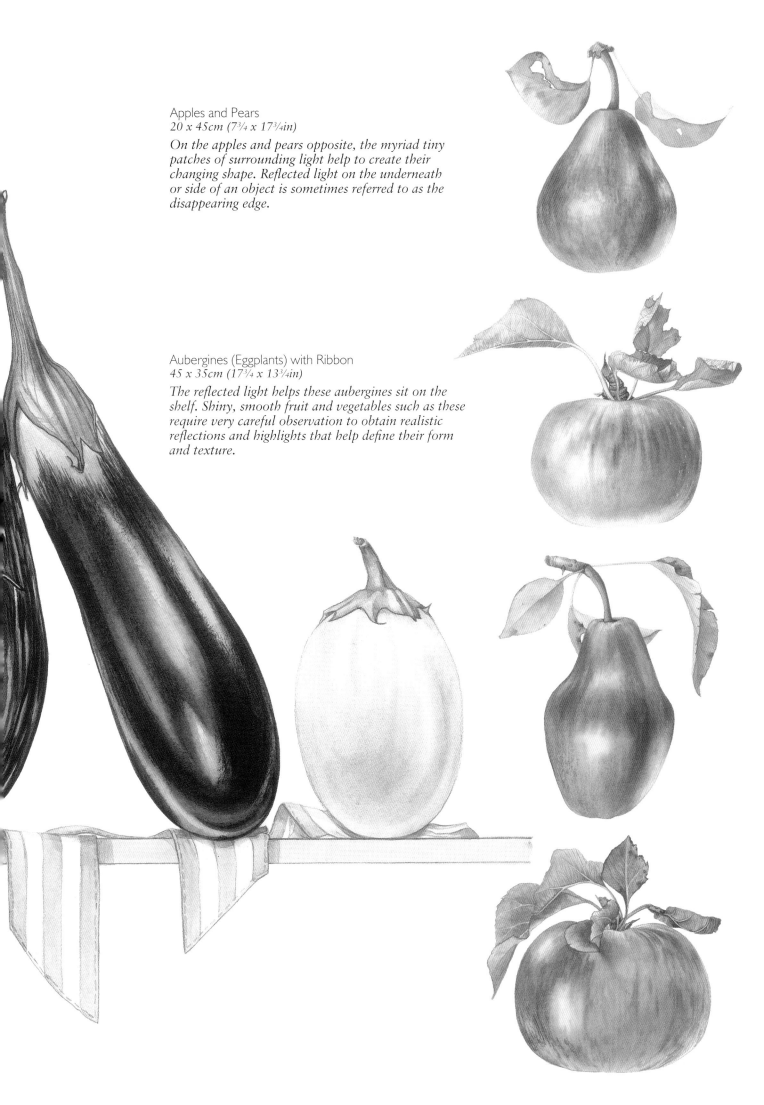

Apples and Pears
20 x 45cm (7¾ x 17¾in)

On the apples and pears opposite, the myriad tiny patches of surrounding light help to create their changing shape. Reflected light on the underneath or side of an object is sometimes referred to as the disappearing edge.

Aubergines (Eggplants) with Ribbon
45 x 35cm (17¾ x 13¾in)

The reflected light helps these aubergines sit on the shelf. Shiny, smooth fruit and vegetables such as these require very careful observation to obtain realistic reflections and highlights that help define their form and texture.

White vegetables

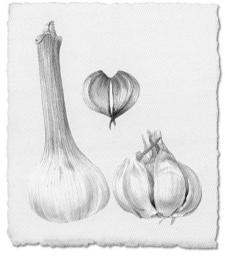

Painting white on white can be difficult to master. It requires subtle colour mixing and careful observation of shadows. Start with something simple, for example a mushroom, and shine some strong light on to it to increase the contrast. You will be amazed at how dark the areas in shadow need to be in order to give the subject dimension. To paint the vegetable, use a variety of shades of the mid-tone colour on page 48 tinted with a little of the local colour. Here I have chosen to paint a wet garlic bulb and a dry garlic bulb to illustrate the gentle changes in colour. Two pink garlic cloves were added to the final picture to complete the composition.

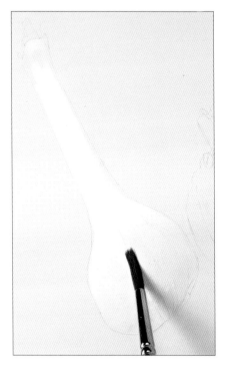

1. Make a mid-tone mix of French ultramarine, cadmium red deep and cadmium yellow pale. Glaze over the fresh garlic on the left with clear water.

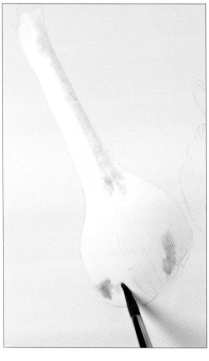

2. Drop in the shadows using the mid-tone mix.

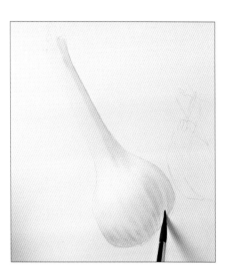

3. Blend in the colour using a damp brush, at the same time lifting out the highlights to form the shape of the bulb.

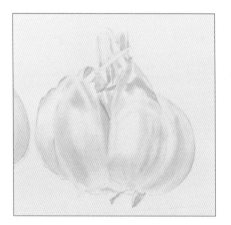

4. Repeat steps 1 to 3 on the dry garlic on the right.

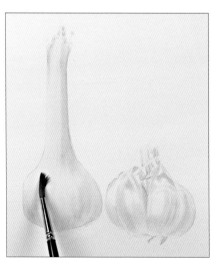

5. Make a very watery mix of pale green using cadmium lemon and a touch of Winsor blue (green shade) and glaze over the stem of the fresh garlic, pulling the colour down into the bulb. Put a small amount of the same colour on the dry garlic. Use a clean, wet brush to blend the wash into the white bulb.

6. Make a stronger version of the same mix for the shoots on the dry garlic.

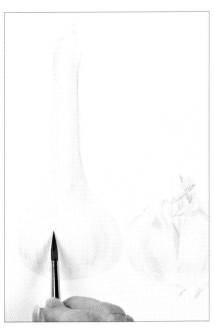

7. When thoroughly dry, remove all the pencil lines, and make an olive green mix of cadmium yellow pale, Winsor blue (green shade) and cadmium red deep. Draw in the veining on the fresh garlic by dragging the tip of the brush down the stem in long, sweeping strokes.

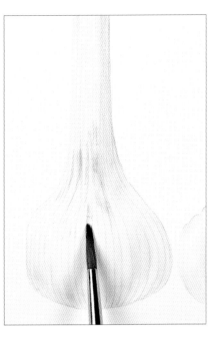

8. Make a mix of quinacridone magenta and French ultramarine and use dry brushing to apply the purple coloration.

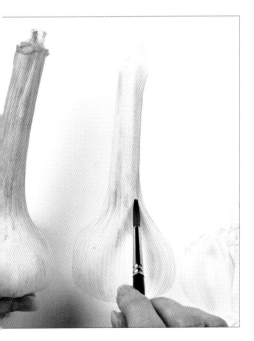

9. Make a stronger olive green mix. Glaze the stem of the fresh garlic with water and add the colour, dragging it down into the bulb. Refer constantly to the vegetable you are painting, ensuring you paint what you can see, not what you think should be there.

10. While the paint is drying, sharpen up the details at the top of the stem.

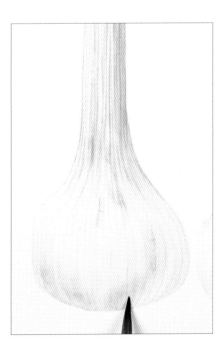

11. Use the strong olive green mix to strengthen the veins. Using the mid-tone grey, strengthen the shadows down the right-hand side of the stem and on the underside of the bulb. Soften them in with a clean, damp brush.

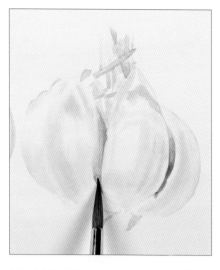

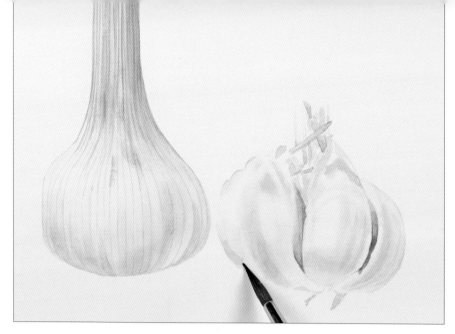

12. Add a little permanent rose and cadmium yellow pale to the mid-tone mix and paint in the pinks in between the cloves of the dry garlic.

13. Using the purple mix (quinacridone magenta and French ultramarine), add extra shadow to the underside of each bulb and soften it in with a clean, damp brush.

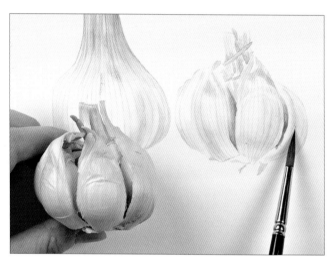

14. Make a mix of the mid-tone with some cadmium yellow pale and paint in the veins on the dry garlic.

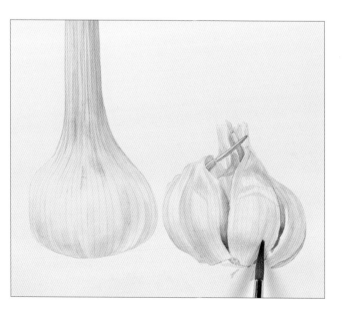

15. Add more shadows to define the folds in the papery skin of the dried garlic. Also, lay a light, yellowy green wash over the interior of the bulb from where the shoots are emerging.

16. Drag a little pale French ultramarine glaze down the left-hand side and underneath the bulb to create more contrast. Finally, make a very pale mix of cadmium lemon and sweep it here and there on the top of each bulb.

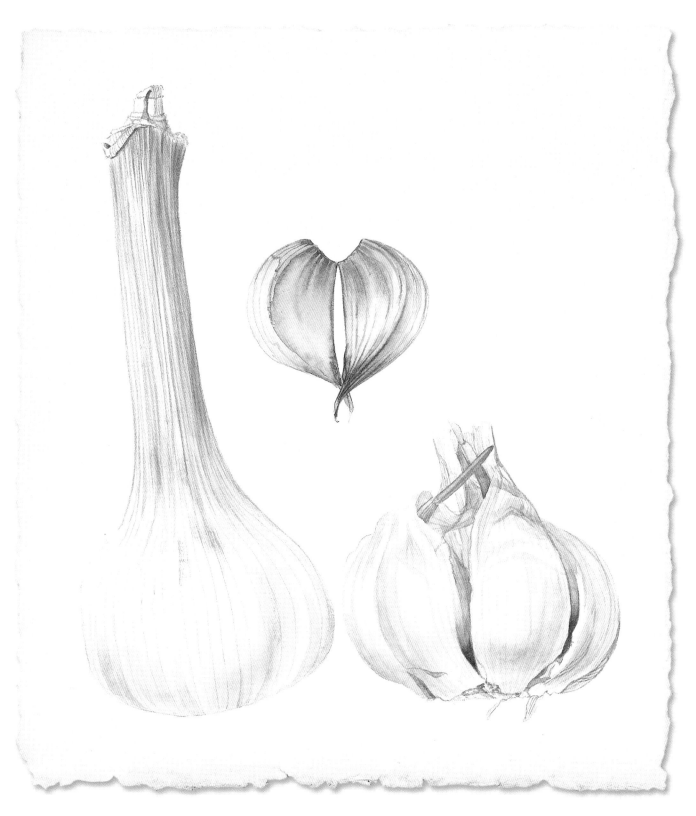

The gentle application of soft grey washes brings the subject to life, and the touches of light underneath give the garlic volume. The two cloves, in the form of a pink heart, add a romantic twist to the finished painting, and fill the space in the middle of the composition.

Flowers and blossom

Runner bean flowers

The beautiful bright orange/red flowers of the runner bean remind me of pixie boots before they open. Use a size 6 brush, keeping it as vertical as possible to achieve tiny strokes, and work quickly to lift out the highlights. Twist the bean flower cluster around to familiarise yourself with the structure before you begin to paint.

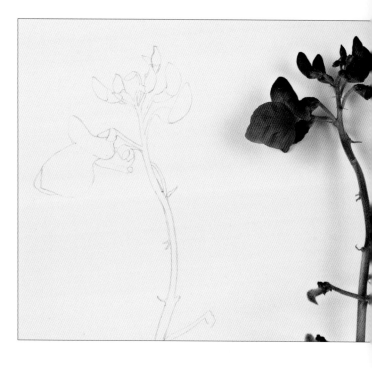

1. Draw the outline of the flower directly on to watercolour paper.

2. Mix the flower colour using quinacridone red and cadmium lemon. Lay a clear water glaze over the main petal of the main flower.

3. Lay in the colour around the highlight.

4. Before the paint dries, lift out any extra highlights on the folds of the petal using a clean, damp brush.

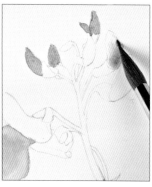

5. While the petal is drying, glaze each bud individually and drop in the same red mix.

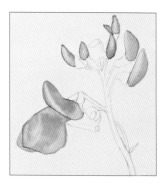

6. Lift out the highlights on the buds and allow them to dry. In the meantime, return to the main flower and lay another water glaze followed by the first wash of colour over two further petals. Lift out the highlights.

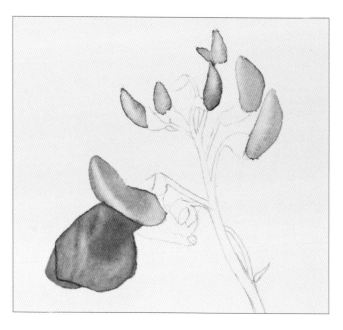

7. Allow the paint to dry and remove any unwanted pencil marks. Make two more mixes: a light orange mix of quinacridone red and cadmium orange, and a stronger version of the first red mix (see step 2). Glaze the petal with water, then apply the first mix followed by the second mix, allowing them to blend naturally on the paper. Lift out the highlights before the paint dries.

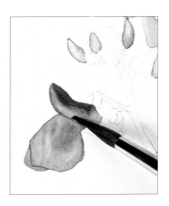

8. While the paint is drying, add another layer of colour to the upper petal, blending it from red at the top to orange at the bottom. Lift out the highlights.

9. Returning to the main petal, use the red mix to add areas of shadow to create folds. When the paint has dried, drag the tip of the brush across the petal to form veins. Use the same colour as in step 7.

10. Continue adding the veins, and strengthen the buds with another layer of the red mix. Avoid painting over the highlights. Map in the final petal on the main flower.

11. Make a green mix of French ultramarine, Winsor blue (green shade) and cadmium lemon. Paint in the smaller stems (there is no need to glaze first), starting at the top and dragging the paint downwards into the top part of the main stem.

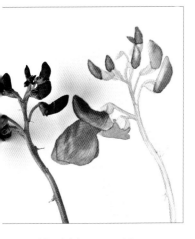

12. Add a second layer of green to build up the colour of the stems where necessary. Pull this wash further down the stem, adding a touch of cadmium red deep near the base.

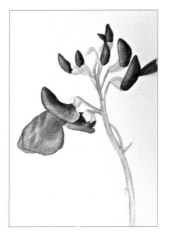

13. Using the mix from step 11, put in some shadows along the edges of the stems. Finally, make a mix of cadmium red deep, French ultramarine and a little quinacridone red and darken the buds and sepals.

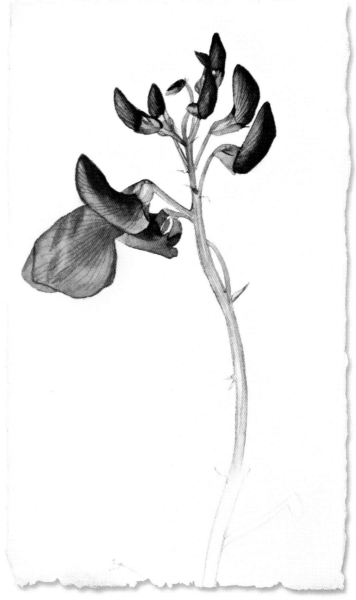

The completed flowers. I have used a slightly darker mix to put in some fine details, applying the paint with the tip of the brush, allowing them to dry, and then softening them in with a damp brush. I also added a little more green to the sepals to strengthen them.

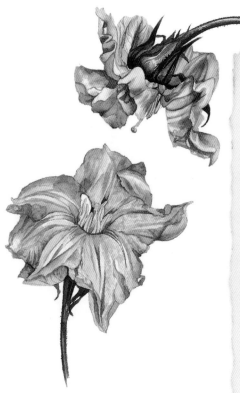

Aubergine (eggplant) flowers

These flowers have a beautiful pink stripe running through the centre of each petal and a wonderful crushed silk appearance. The colour was a mix of mauve, opera rose and French ultramarine. The texture was achieved by pressing a crushed tissue into the wet glaze and then enhancing the folds with deeper shades of the colour mix.

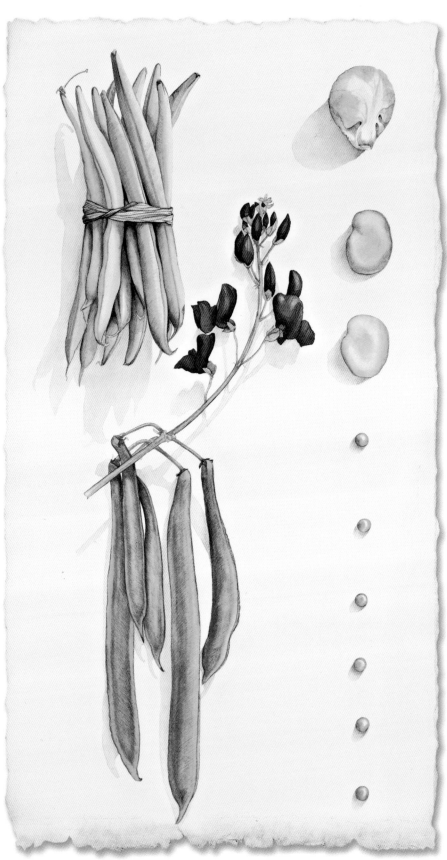

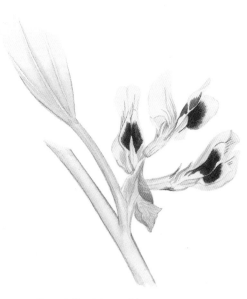

Broad (fava) bean blossom

Once the shadows have been painted to depict the shape of the flowers the detail is added with a mix of indigo and cadmium red deep.

Beans, Peas and Sprout
50 x 70cm (19¾ x 27½in)

The red flowers make a striking central focal point for this painting of green vegetables.

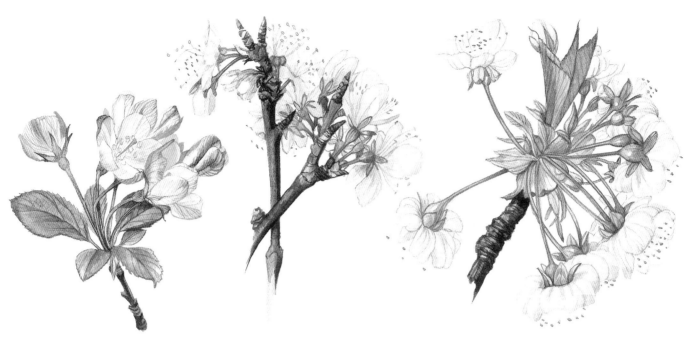

Crab apple, plum and cherry blossom (left to right)

Crab apple blossom is so pretty and much easier to paint than the pale plum and cherry blossom. Patience and speed are required in equal measure as blossom fades quickly once cut.

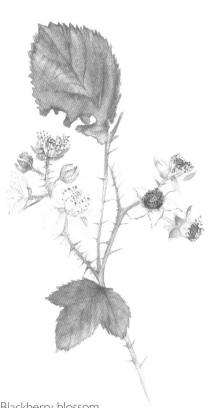

Blackberry blossom

This painting required very careful observation of the subtle changes in the cream colour of the petals and the colour of the thorns. I used a pointed No. 4 brush and mixed a wide range of greens ready for use before I started to paint so that I could blend the colours on the paper.

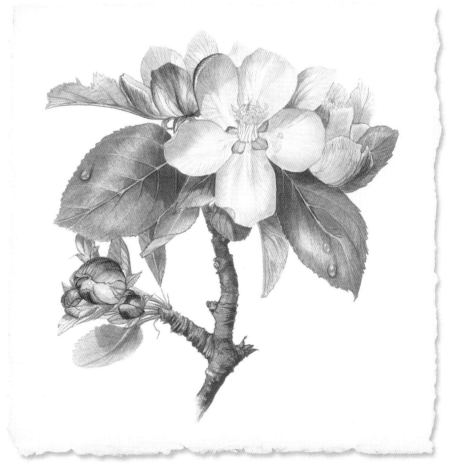

Apple blossom

The soft mid-tone mixed with pink really brings the centre of the petals to life. I love the contrast of the deep pink bud with the pale open blossom. The addition of the water droplets gives a fresh feel to the composition, reminiscent of a spring day after gentle rainfall.

Painting details

Adding detail to your painting is essential if it is a botanical study, and it must be accurate. However, not every part of the plant needs to be heavily detailed – as the plant twists and turns, some features will be lost in highlight or shadow. A common assumption is that it is essential to use tiny brushes for putting in detail, but I have found that a well-made, fine-tipped No. 6 or No. 4 brush will do very well. The trick is to twist the brush as you collect the paint to draw the hairs into a fine point and, keeping it as vertical as possible while you work, draw rather than paint on the details. If the detailing is done at an early stage of the painting, you can lay a softening glaze over the top, thus pulling the detail into the picture rather than have it floating on top of heavy colour washes.

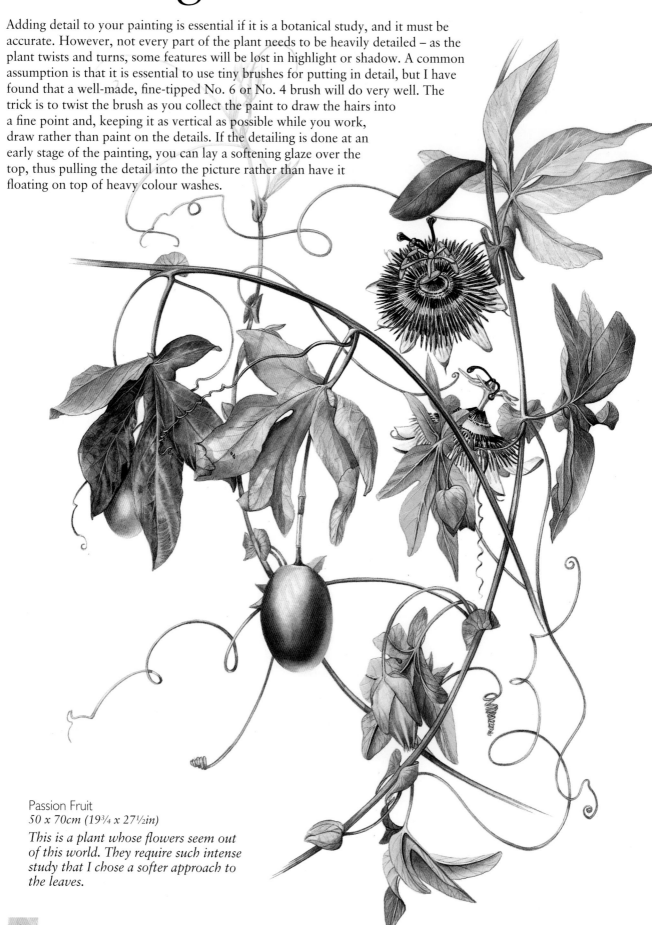

Passion Fruit
50 x 70cm (19¾ x 27½in)

This is a plant whose flowers seem out of this world. They require such intense study that I chose a softer approach to the leaves.

Sweetcorn

You may wish to break a complicated subject such as a corn cob into sections. I try to map out the kernels and identify an area that I can locate easily as I paint. Sometimes I mark one of the kernels with a small spot of white paint and use it as a reference point. When I have mixed a particular colour, I try to paint as many areas that are that colour as I can. This saves time overall, and avoids having to remix the same colour more than once. The most important thing is to maintain the individual highlights throughout each stage.

1. Choose an area that is easy to locate on the cob and glaze one kernel.

2. Paint in the colour, leaving the highlight white.

3. Paint all the remaining kernels that are the same colour, glazing each one with clear water first. Allow the paint to dry.

4. Continue in the same manner, painting all the kernels of one colour before moving on to the next.

5. Complete all the kernels and allow them to dry.

6. Rub out the pencil lines. Strengthen the colour of the kernels and intensify the shadows between them using stronger versions of the same mixes.

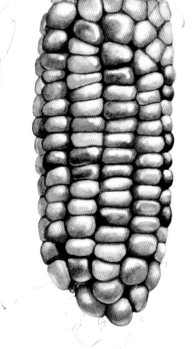

61

Courgette (zucchini)

The courgette looks complicated, but if you break down the patterns it becomes an enjoyable exercise. The flowers are always beautiful to paint, whether open or twisted as they curl and die away. You will need a growing plant as you may require more than one bloom to complete the picture.

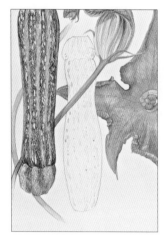

1. Apply masking fluid to the white patches down the length of the courgette (see page 44). Allow it to dry thoroughly.

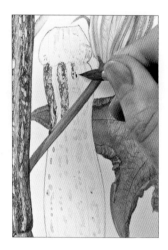

2. For the dark green stripes, make a concentrated mix of French ultramarine and cadmium yellow pale. Holding the brush close to the tip for greater control, apply the paint to dry paper using the tip of the brush and small, circular movements.

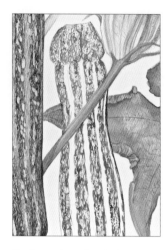

3. Complete the dark green stripes. Add a little yellow to the mix and paint the stalk using similar marks.

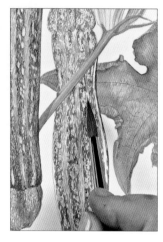

4. Make a pale green mix of cadmium yellow pale and Winsor blue (green shade), and paint in the pale green stripes using short, sharp brush strokes.

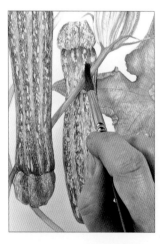

5. Complete the pale green stripes, then water down the initial dark green mix and glaze over the shaded areas at the top and bottom of the courgette, softening the glaze into the background colour using a clean, damp brush.

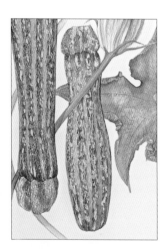

6. Water down the pale green mix and glaze down the right-hand side of the courgette.

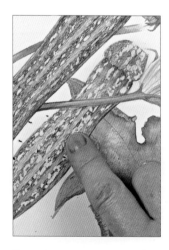

7. Allow the painting to dry thoroughly and carefully rub off the masking fluid with your finger tip.

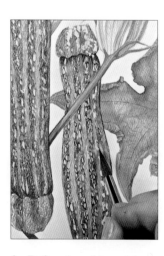

8. Define the white patches revealed underneath by outlining them using the dark green mix with a small amount of indigo added to it. Apply the paint with the tip of the brush.

9. When dry, glaze over the whole courgette using a pale wash of the lighter green. This softens the painting and gives it more colour, plus it tones down the white marks to a more natural colour.

10. Finally, add the shadow of the flower stalk by dragging a pale wash of the darker green across the courgette and part of the flower.

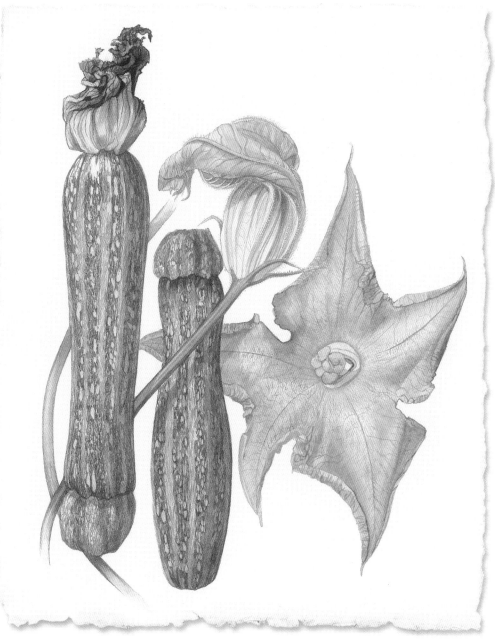

The completed painting. I have strengthened the darker areas and the details where required to finish, using the dark green glaze.

Artichoke

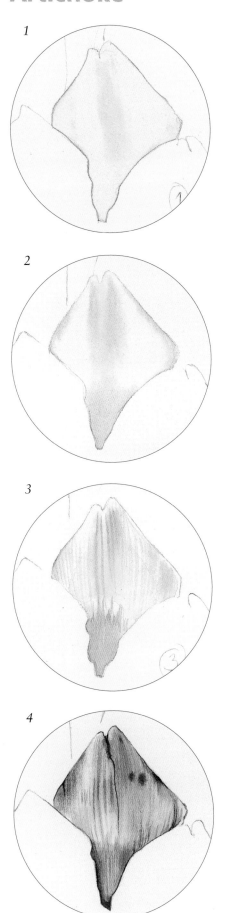

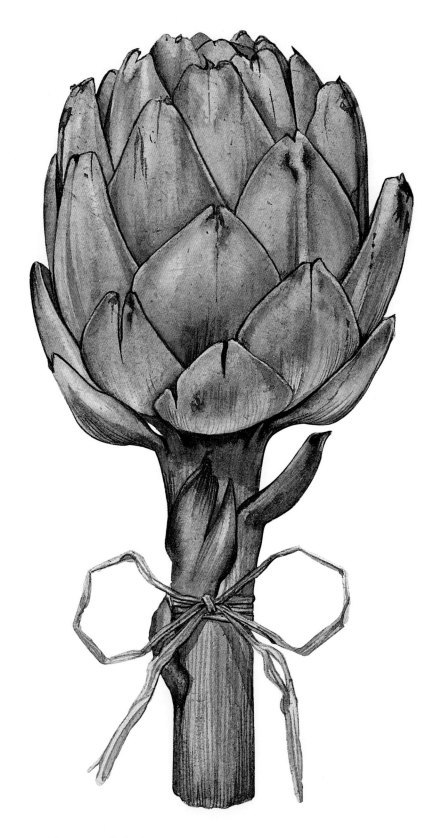

Artichoke with Raffia Bow

Pictures 1 to 4 on the left show the preliminary stages of this painting, before the delicate details are added. Begin by laying on a green glaze and lifting out the light (1). Allow to dry. Glaze with water, and add deeper greens to define the folds and shadows (2), then drag on the veining and details (3). Allow to dry. Glaze over a soft green to intensify the colour, and use darker browns and greys to apply the various surface blemishes and deeper shadows (4).

Black beans

Black Beans in Green

Once the beans are mapped out, lay on a deep purple glaze. Lifting out the highlights will leave areas of mauve with a soft edge (1). When dry, lay on a second dark glaze and lift out the highlights again (2). They will darken each time you lift them out. Lastly, dry brush on the texture and details and deepen any shadows that require strengthening with another dark glaze (3).

65

Red corn

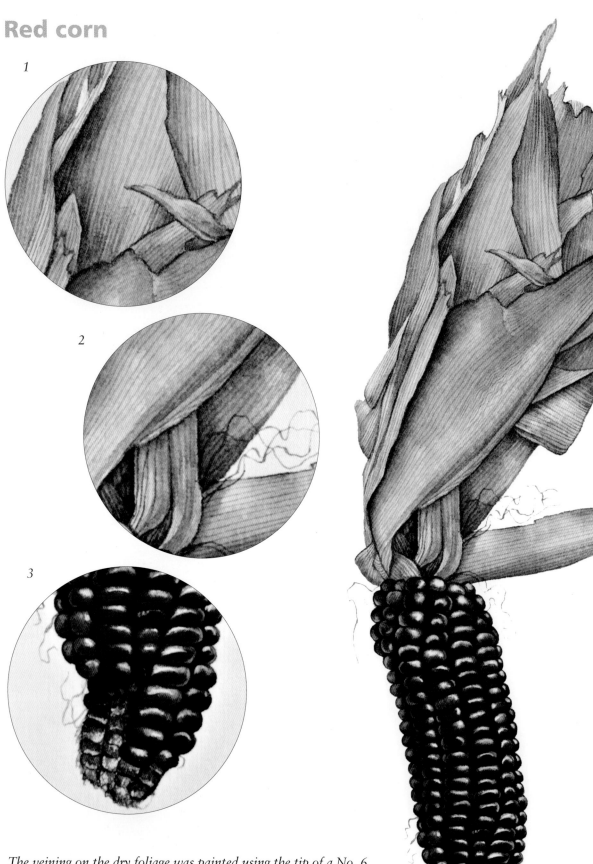

1

2

3

The veining on the dry foliage was painted using the tip of a No. 6 brush in various tones of brown (1). The same brush was used to add the loose fibres, pushing and twisting the brush up and down to create different thicknesses of line (2). The kernels were painted following the method shown on page 61 using the wet-into-wet technique, whereas the parts where the kernels are missing at the tip of the cob were painted with a dry brush (3).

Asparagus

Asparagus is more complicated to paint than appears at first glance. The main stem has a soft highlight and often shows subtle changes in colour from green to purple. The individual leaves have their own colour, which also varies, with small highlights at the base. To paint, first glaze and lay in the green for the main stem, then add in the colours and detail for each leaf. When painting a leaf, retain a narrow border of white paper to represent the pale edge. Soften the veining on the stems with a damp brush.

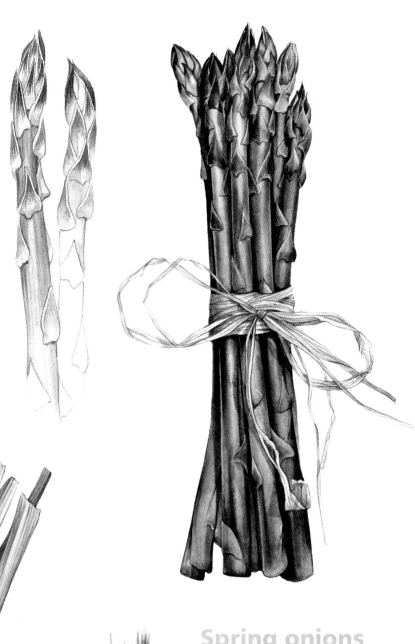

Spring onions

It is a tradition of botanical illustration to add roots to a study for aiding identification of the plant. The addition of roots also provides extra detail and softness to a study and helps with the composition.

The roots of the spring onion are painted with the tip of a No. 6 brush using a variety of warm and cool greys and mid-tone mixes. The patterning on the onion is applied on to a wet glaze and then the tip of the brush dragged through as it dries.

Small fruit

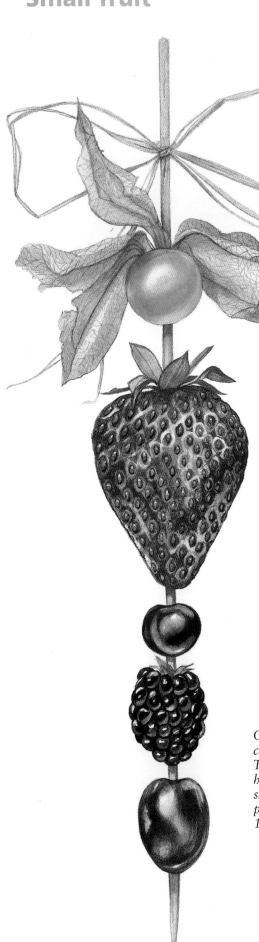

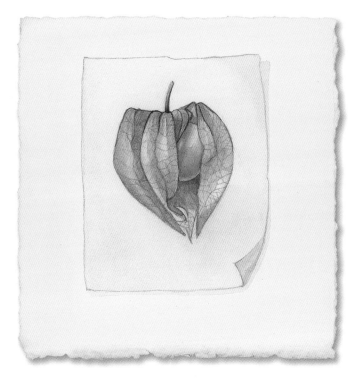

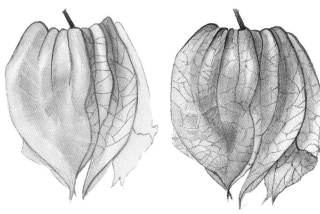

Physalis (cape gooseberry)

The papery petals that encapsulate the physalis berry have a complicated network of veining. Not all are dark, so be careful to lift out the pale veins before the colour glaze dries.

Composing this kebab of berries, I separated the very complicated fruits by placing smooth fruits in between. The highlights must be small, bright and descriptive to help create form. Detailed instructions for painting strawberries, blackberries and blueberries are provided in the final demonstration on pages 118 to 127.

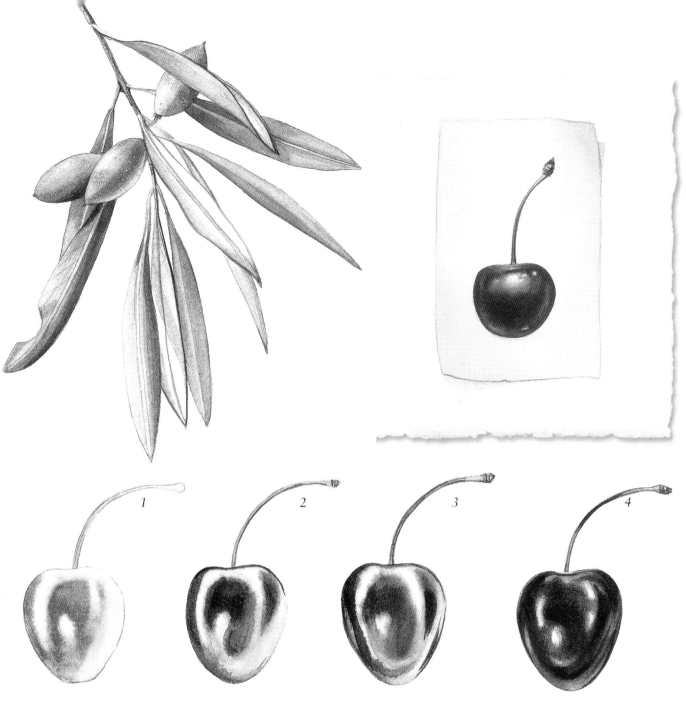

To create a simple black cherry, drop small amounts of paint on to a water glaze around the highlights and allow to dry (1). Repeat step 1 using a stronger colour mix (2). Using the dry-brush method, strengthen the colour further in the dark areas (3). Continue to dry brush on the darkest mix and then pick out any small highlights with a scalpel (4).

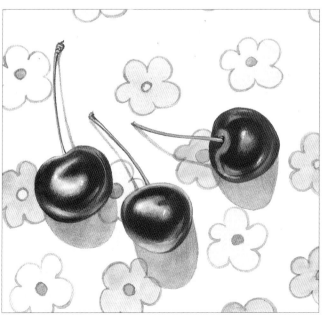

Red cherries

A multitude of reds is required to develop the rich, glossy surface of the red cherry. You need to concentrate hard to retain the highlights, lifting them out continually as the paint dries. The colourful background lifts the composition, giving a sense of summer picnics.

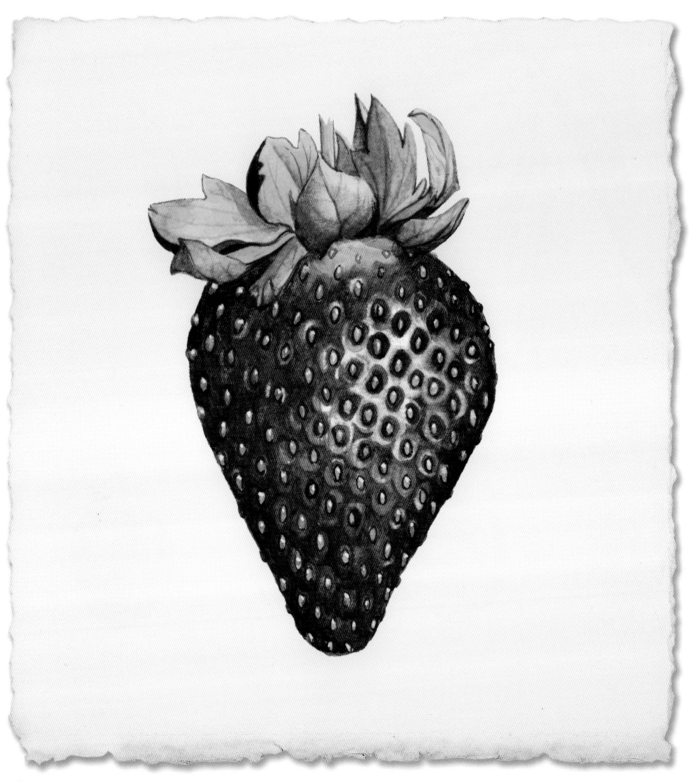

Strawberry
Original 10 x 12cm (4 x 4¾in); print 30 x 40cm (11¾ x 15¾in)

This was one of the first strawberries that I painted, and the first time that lifting preparation really helped. The image worked so well at the larger-than-life size that I enlarged it even further when I had prints made.

Cherries
21 x 27cm (8¼ x 10¾in)

This sprig was given to me by a group of cherry pickers. It was a hot day and the leaves drooped beautifully to complement the curve of the cherry stems.

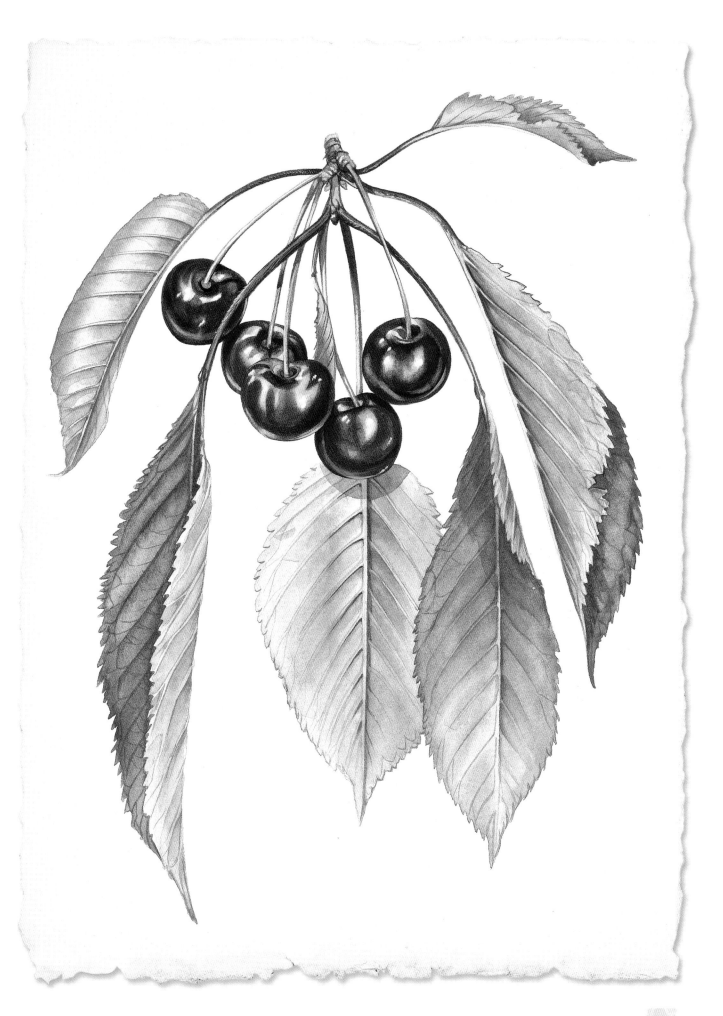

Projects

The step-by-step projects that follow are of four very different fruit and vegetables, my intention being that everyone will be inspired to paint at least one of them. The elegant, leafy kohlrabi is a wonderful study in the use of greens, and can be further embellished by the addition of some bright orange nasturtiums. The pumpkins provide a more traditional still life composition, and the timeless simplicity of the single lemon means it would be equally happy adorning the walls of either a modern kitchen or a medieval manor house. Yellows are notoriously difficult to get right, and this project provides the perfect vehicle for practising working with them. The final project – the berry-filled heart – is a little more whimsical, though arguably the most difficult and time-consuming of the four.

All of the projects put into practice the techniques described earlier in the book, and therefore provide the perfect way of developing your watercolour painting skills. I have provided as much detail as I can in the step-by-step instructions, including which colour mixes to use; however, if you choose to paint your own fruit or vegetable, refer to the instructions as a guide only, and mix colours that are true to your particular specimen.

Kohlrabi, page 74

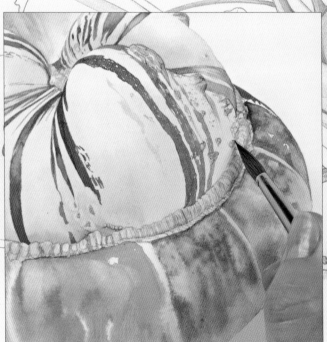

Pumpkin Still Life, page 90

Lemon, page 106

Heart of Berries, page 118

Kohlrabi

Kohlrabi is not a very commonly known vegetable, but it is easy to grow and very attractive to paint. It is, however, very popular with caterpillars, hence I have chosen a plant that was not too badly damaged. The holes, though, add a pretty, lacy touch to the leaves which is very appealing.

The kohlrabi was supported in the top of a glass bottle, with the root immersed in water, while I painted it. At night, I stored it in the fridge to keep it fresh. If you choose to paint your own kohlrabi, observe it from all angles before deciding on the best view to paint; I chose this composition because the leaves were beautifully placed to show both the upper and lower surfaces.

This painting is a wonderful way of practising mixing greens and painting veins. It also involves the use of masking fluid to obtain the holes in the leaves, and lifting out colour to create highlights on the smooth surface of the bulb (see page 40). All of the techniques you need to produce a successful painting are explained on pages 38 to 51; how to mix greens is described on pages 32 to 33.

As an extension to this project, I used the tracing method (see pages 20 to 21) to draw the kohlrabi in pencil behind the painted one to increase the 'lacy' feel of the study (see pages 86 to 87). This stage is, of course, optional, as is the addition of the bright orange nasturtiums shown on pages 88 to 89.

Materials

Sheet of hot-pressed watercolour paper, 60 x 45cm (23½ x 17¾in)

HB pencil

No. 6 sable brush with a fine point

Pencil eraser

Roll of kitchen paper or soft cotton cloth

Masking fluid and small, fine-tipped synthetic paintbrush

Watercolour paints in cadmium yellow pale, Winsor blue (green shade), cadmium red deep, French ultramarine, cadmium lemon, cobalt blue and titanium white (for the nasturtiums you will also need cadmium orange and permanent rose)

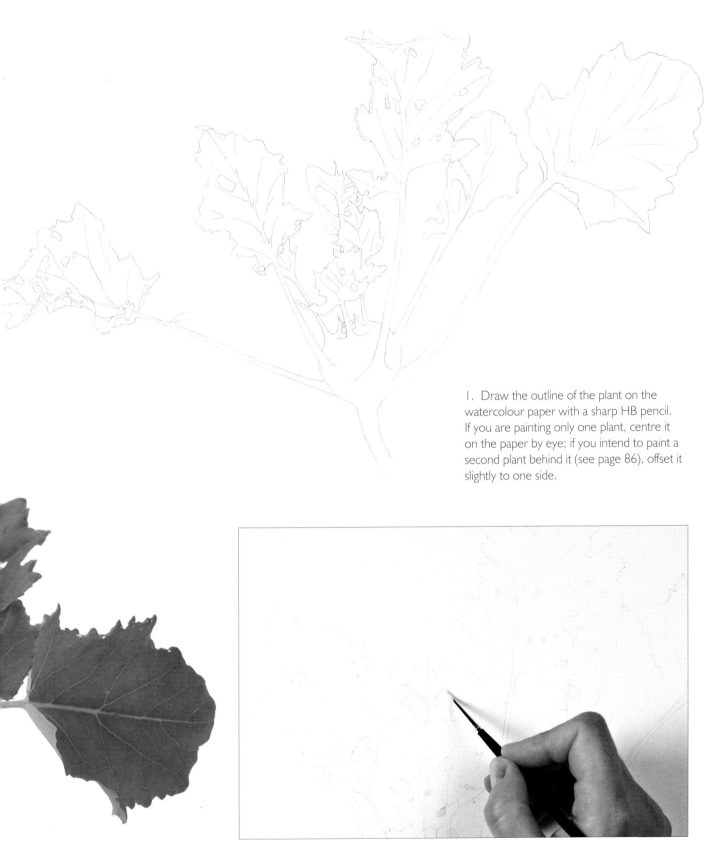

1. Draw the outline of the plant on the watercolour paper with a sharp HB pencil. If you are painting only one plant, centre it on the paper by eye; if you intend to paint a second plant behind it (see page 86), offset it slightly to one side.

2. Apply masking fluid to the holes in the leaves. Paint on the masking fluid using a very small, synthetic brush. Clean the brush regularly to avoid it becoming stiff as the masking fluid dries.

3. While the masking fluid is drying, soften the pencil lines by dabbing them firmly with an eraser.

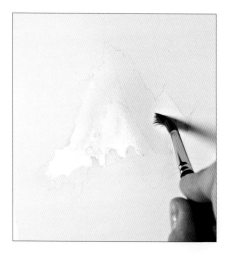

Tip

If you are right-handed, always start painting on the left and work towards the right; right to left if you are left-handed.

4. Make a mix of cadmium yellow pale, cadmium lemon, Winsor blue (green shade) and a little cadmium red deep. Dampen half of the leaf on the far left-hand side of the painting using the No. 6 brush.

5. Stir the mix you have just prepared and paint it on to the glazed area of the leaf.

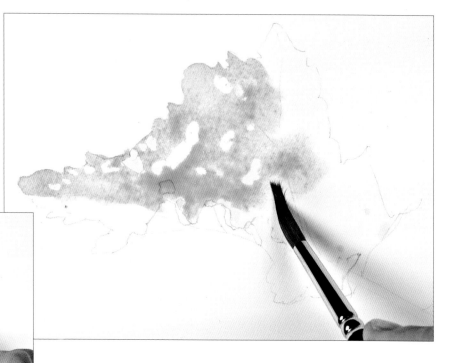

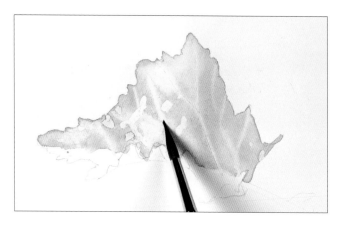

6. Lift out any excess paint with a damp brush, including any areas of highlight.

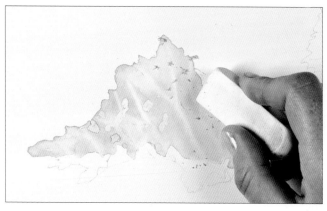

7. Drag the tip of a damp brush through the glaze to lift out the paint where the veins are. Allow the paint to dry.

8. Erase any pencil lines you no longer need, being careful not to dislodge any of the masking fluid.

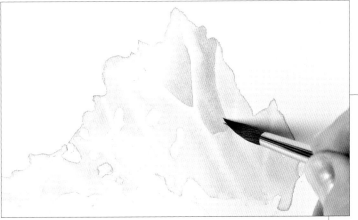

Tip

Be careful not to lose the highlights you have lifted out.

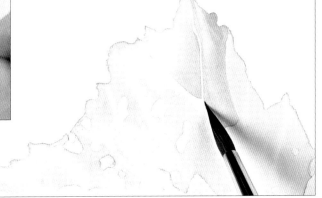

9. Strengthen the mix by adding a little more Winsor blue (green shade) and cadmium yellow pale to make it slightly more blue-green. To define the veins, put in a little more colour between them, glazing the areas you wish to paint first.

10. Drag the tip of the brush along the edges of the veins to strengthen them and narrow them down. Continue this process across the leaf.

The leaf completed to this stage.

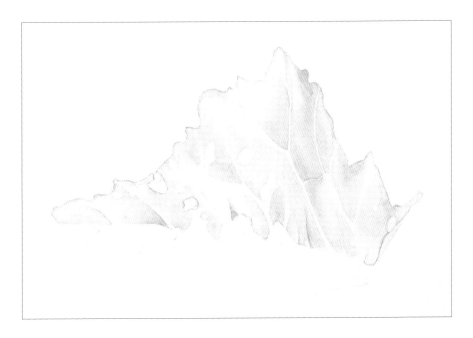

11. When the first half of the leaf has dried, dampen the other half and apply the first mix as before (see steps 4 and 5). Lift out the veins.

12. Working on a dry background, strengthen the green on the edge of the leaf where it curls over.

13. Add a little French ultramarine to the mix and use the tip of the brush to add some shadows along the lower edge of the leaf.

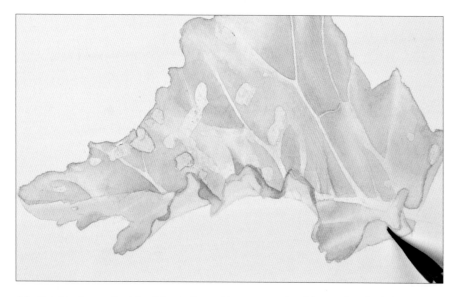

14. Paint in the underside of the leaf, working wet on dry. Use a mix of Winsor blue (green shade), cadmium lemon and a touch of cadmium red deep.

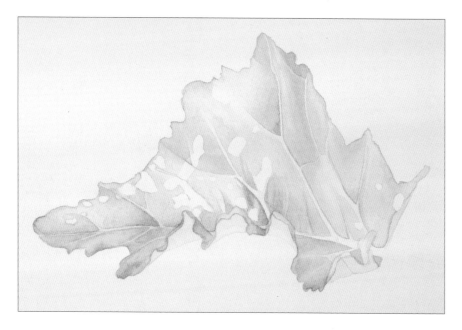

15. Leave the paint to dry, then remove the masking fluid by rubbing it off with your finger. Erase any remaining pencil marks you no longer need.

16. Make a slightly darker green mix using French ultramarine, Winsor blue (green shade) and cadmium yellow pale and add a small amount to the edges of the leaf and the veining where required to help define the details. Soften each application of paint with a damp brush.

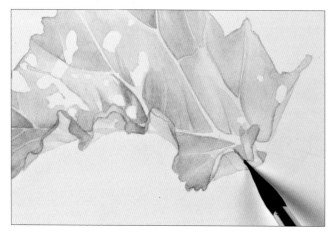

17. Add some shadows to the underside of the leaf using a mix of French ultramarine and cadmium yellow pale. Soften them with a damp paintbrush.

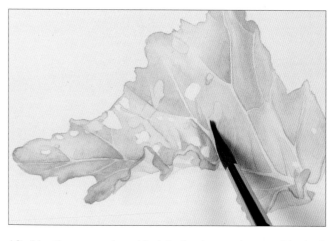

18. Use the same mix to block in the damaged parts of the leaf.

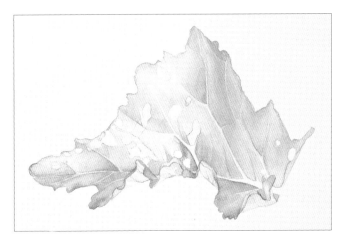

19. Glaze over the parts of the leaf that are in the shade using a watery mix of cadmium lemon.

20. Lay a pale glaze of cobalt blue along the mid rib, and add the fine veins and folds using the original green mix (see step 4).

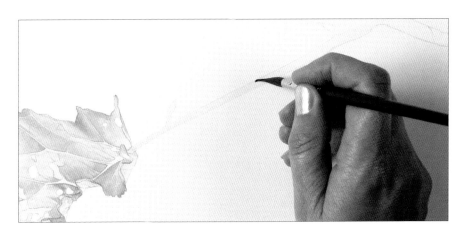

21. Make a mix of cadmium lemon and cadmium red deep. Lay a clear glaze of water along the stem, including the tiny leaf. Turn your work so that you are moving the brush horizontally. Apply colour to the top of the stem and pull it along towards the base using a clean, wet brush so that it becomes progressively paler. Repeat the process immediately if you need to deepen the colour.

22. While the paint is still wet, add a fine line of grey-green (French ultramarine with a touch of cadmium yellow pale) along the top edge; soften this into the stem with a clean, damp brush.

23. Paint in the mid rib and stem of the adjacent leaf in the same way, softening the colour with water at the base.

24. Move to the next leaf along, which has its underside uppermost. Mix some Winsor blue (green shade) and cadmium lemon, and apply the paint over a clear glaze to the left-hand side of the leaf.

Tip

Keep this mix well stirred because it will tend to separate out.

25. Lift out the veins using the tip of a clean, damp brush.

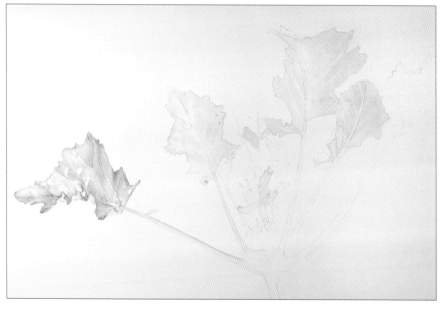

26. While the paint is drying, map in the undersides of the remaining leaves using the same mix. Take care to lift out the veins where necessary before the paint dries completely. Once it has dried, remove any pencil marks you no longer need.

27. Strengthen the mix and paint in the areas between the main veins. Once these are dry, continue with the same colour, filling in the areas between the finer veins.

28. When you have mapped in all the veins in this way, place shadows to one side of the main veins using the same mix.

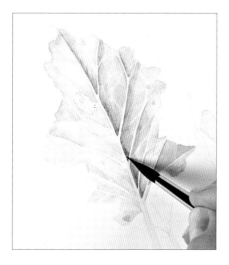

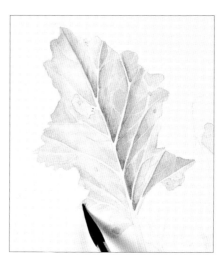

29. Add some French ultramarine to the original mix to darken the colours and deepen the shadow down the right-hand side of the mid rib.

30. Make a weak mix of cadmium yellow pale, cobalt blue and cadmium lemon, and lay a light wash over the left-hand side of the leaf.

31. While the paint is drying, mix some cadmium lemon, Winsor blue (green shade) and a touch of cadmium red deep. Make a light wash and lay it over the mid rib, along the side facing away from the light. Just before it dries, soften the paint into the stem.

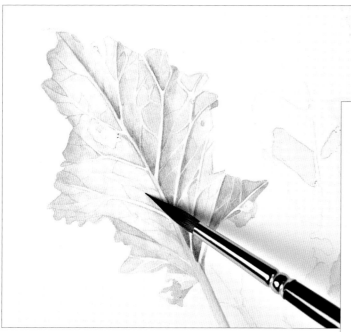

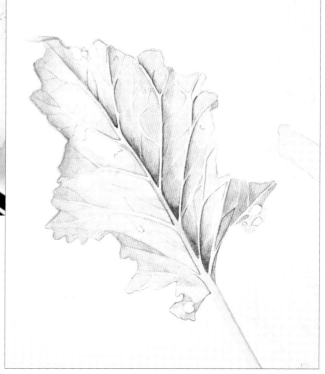

32. Make a bluer mix of cadmium lemon, cadmium yellow pale and cobalt blue, and strengthen the shadow around the left-hand edge of the leaf and within the creases. When the paint has dried, add a little shadow to the sides of the fine veins where necessary.

33. Allow the paint to dry, and remove the masking fluid and any remaining pencil marks. Further strengthen the veins and the shadows as required.

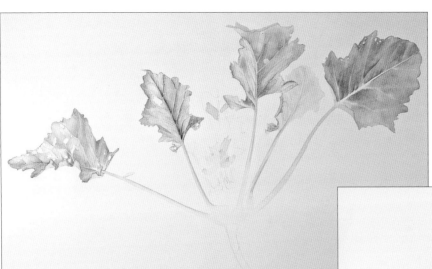

34. Continue building up the remaining leaves using the same methods.

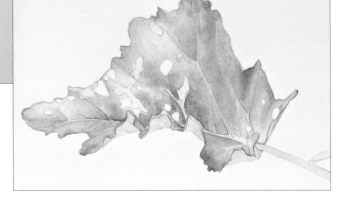

35. Returning to the first leaf, deepen the colour by laying a glaze of cadmium yellow pale, French ultramarine and Winsor blue (green shade) over an initial clear glaze of water. Work carefully around the holes, and drop on the colour patchily to create texture.

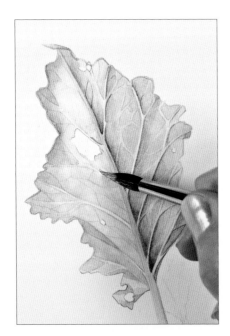

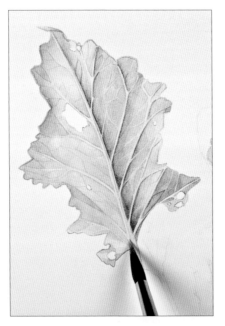

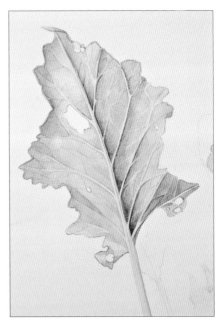

36. Moving on to the adjacent leaf, glaze with water then apply a fairly opaque wash of titanium white to mimic the bloom on the left-hand side. The white will fade quickly to reveal the detailing underneath.

37. Add a little cadmium lemon to the white, and when the glaze has dried draw a thin line of the mix along either side of the mid rib and part of the way up the main veins. Use this method to redefine any of the veins that have been lost.

38. Add white to the lighter parts of the right-hand side of the leaf and soften them in.

Tip
White paint should be used sparingly, and only for painting the 'bloom' present on the leaf surfaces of certain plants.

39. Make a watery, pale mix of cadmium lemon and Winsor blue (green shade). Glaze the bulb with water, taking the glaze right up into the smaller stems. Add the colour by placing it in the stems first, and dragging it down into the bulb. Maintain the bright highlight by painting around it.

40. Fade out the colour towards the base of the bulb. While it is drying, lift out paint from the top of the bulb to create highlights, and also any that has flooded into the main highlight.

41. Continue to add colour to the base of the bulb and the root, lifting out the highlight. Allow the paint to dry.

42. Remove any unwanted pencil marks, add a little more colour to the wash and paint in small amounts of colour where the stems meet the bulb. Drag some of the colour up the right-hand sides of the stems to create shadow. Soften these marks using a clean, damp brush.

43. Make a blue-green shadow mix using cadmium lemon, Winsor blue (green shade), French ultramarine and a touch of cadmium red deep. Put the shadows on the bulb and lower parts of the stem, glazing the areas with water first. Be careful not to make the shadows too heavy.

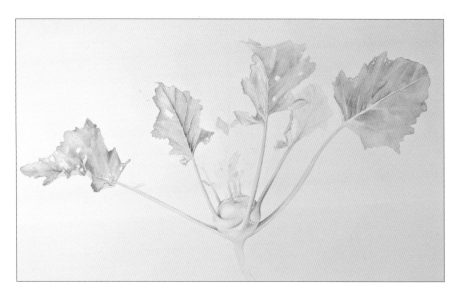

44. Complete the shadows. Make a watery mix of Winsor blue (green shade) and cadmium lemon and run a little of the colour down the left-hand sides of the stems to strenghten them. Remember to change the angle of the paper so that you paint the stems horizontally. Use the same mix to add a little more colour to the bulb where needed. Soften in the colour with a clean, wet brush.

45. Using a watery mix of titanium white, lay a light wash over the areas of the bulb where the bloom is visible. Soften it in with a damp brush.

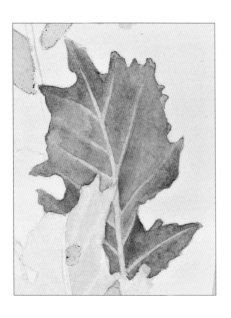

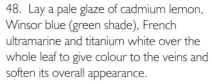

46. Start to paint the small leaves using a mix of cadmium lemon, French ultramarine, a little cadmium red deep and a touch of Winsor blue (green shade). Paint half a leaf at a time, glazing first and then dropping in the paint. Just before it dries, lift out the veins with the tip of a clean, damp brush.

48. Lay a pale glaze of cadmium lemon, Winsor blue (green shade), French ultramarine and titanium white over the whole leaf to give colour to the veins and soften its overall appearance.

49. Paint the other small leaves in the same way, building up the colour and deepening the shadows where necessary.

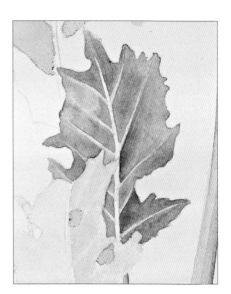

47. Use the same wash to darken the colour in-between the veins, thereby accentuating them.

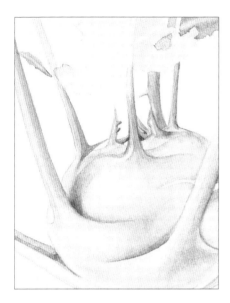

50. Make a chalky, pale green mix using cadmium lemon, Winsor blue (green shade) and titanium white and use it to define the small stems.

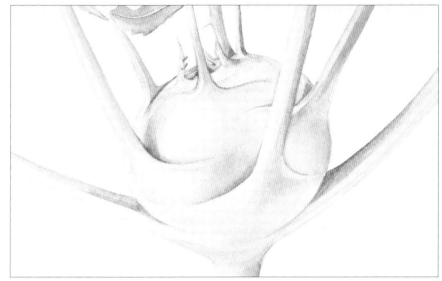

51. Lay a light glaze of cadmium lemon and Winsor blue (green shade) to bring up the colour on parts of the bulb that need brightening.

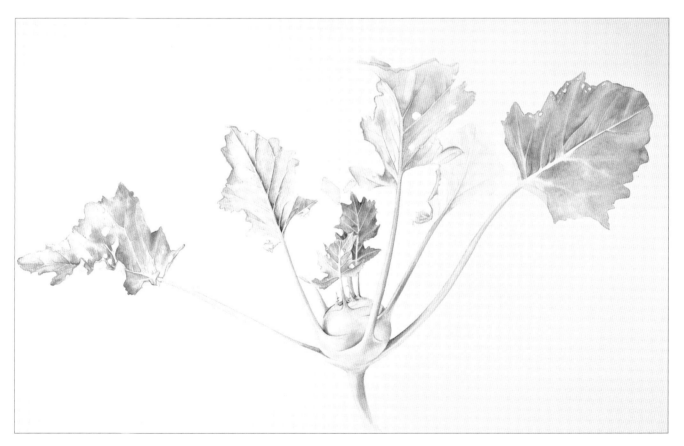

The painting, completed so far.

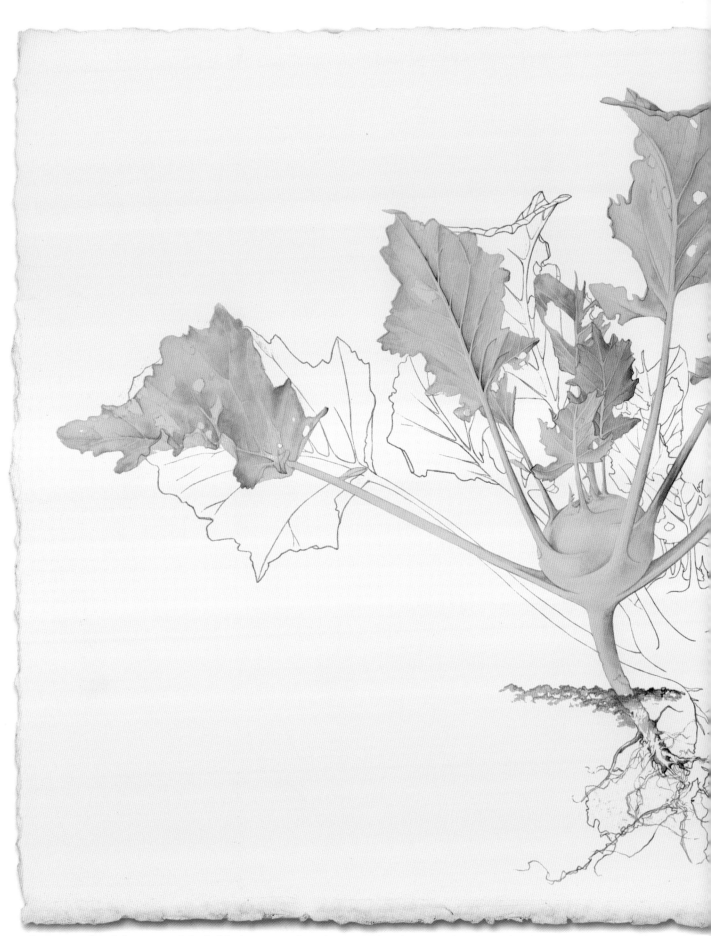

I have completed the roots of the kohlrabi in pencil, and suggested soil in pencil too. The kohlrabi was then drawn again, in reverse, behind the painting, to give a lacy feel to the picture.

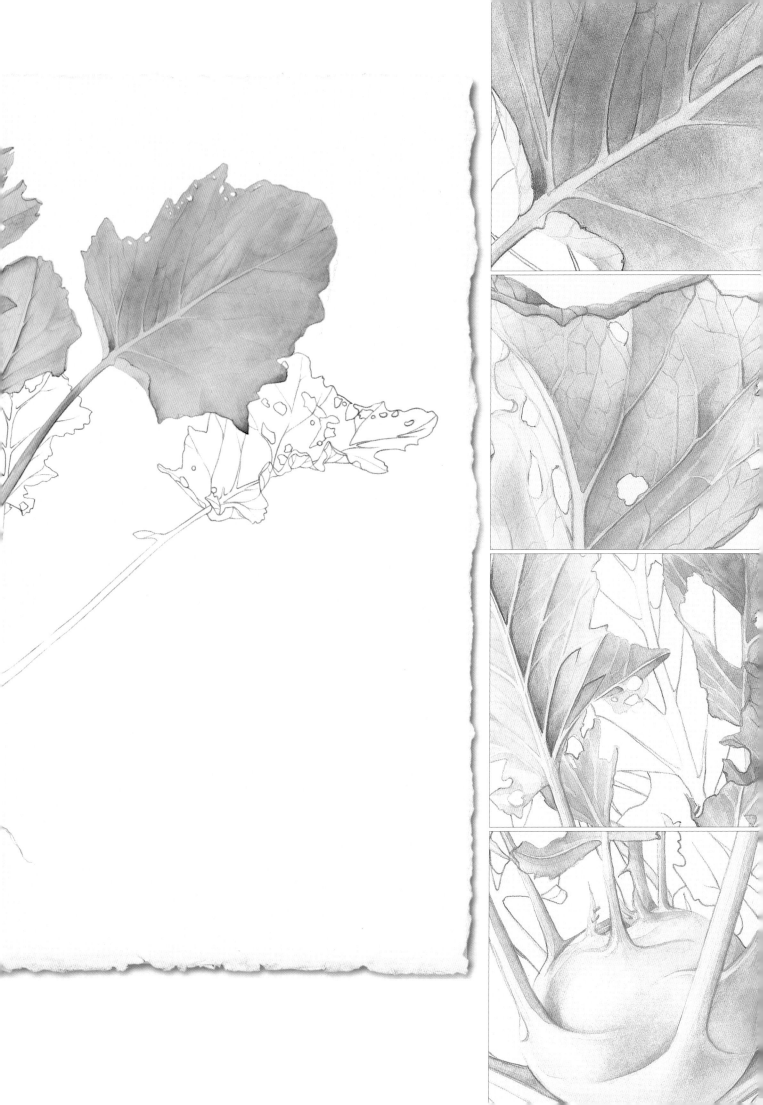

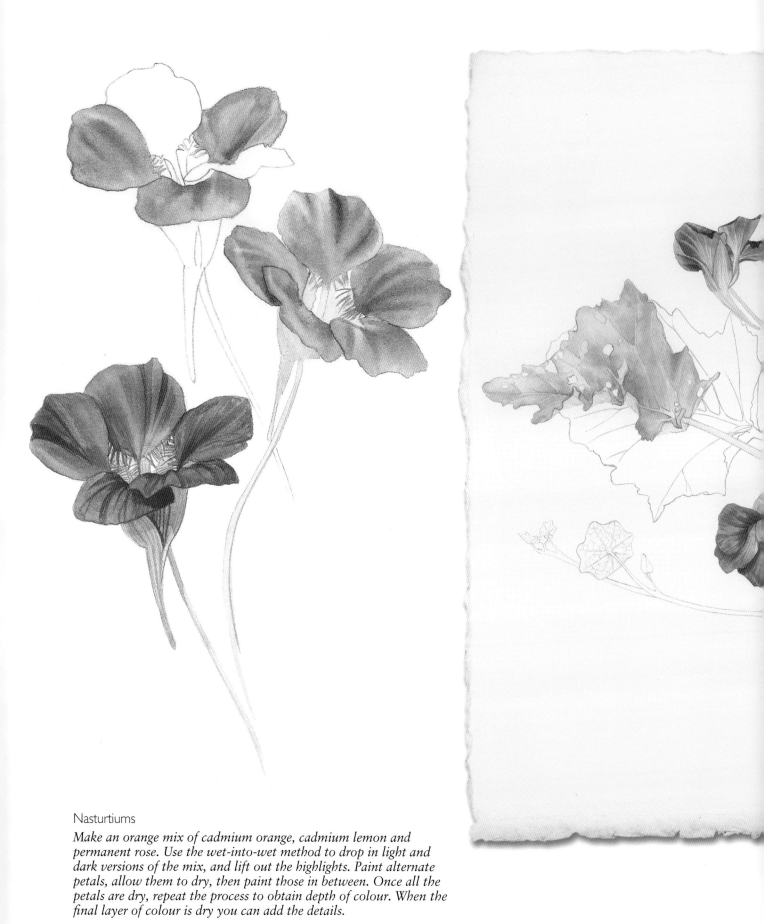

Nasturtiums

Make an orange mix of cadmium orange, cadmium lemon and permanent rose. Use the wet-into-wet method to drop in light and dark versions of the mix, and lift out the highlights. Paint alternate petals, allow them to dry, then paint those in between. Once all the petals are dry, repeat the process to obtain depth of colour. When the final layer of colour is dry you can add the details.

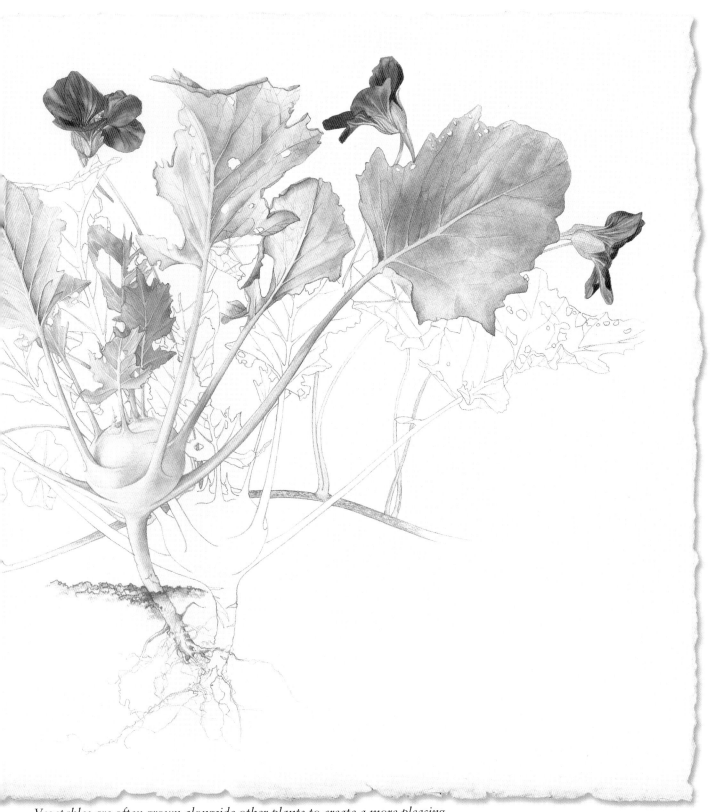

Vegetables are often grown alongside other plants to create a more pleasing display in the garden. The cool blue-green of the kohlrabi, for example, is beautifully complemented by the hot orange of the nasturtiums. Here, the addition of the flowers helps emphasise the overall shape of the plant, and also adds a pleasing touch of colour.

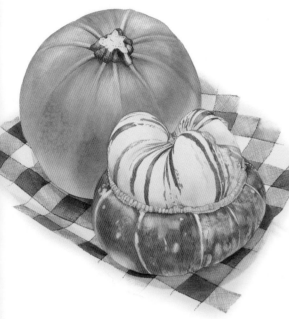

Pumpkin Still Life

There are endless varieties of pumpkins and squash, and their vivid colours and unusual patterns and textures make them great fun to paint. I have chosen two very different types that contrast well with each other. The larger fruit, the pumpkin, is bright orange in colour and has little surface detail. On the other hand, the smaller of the two, the Turk's turban squash, is brimming with character in the form of strong, brightly coloured markings, surface bumps and gnarls, and a shape that is reminiscent of an exotic headdress (hence its name). I have placed both fruit on a blue chequered cloth that complements the orange and creates a strong, cohesive composition.

Once completed, I decided to add some additional texture and heavier contrast to the background in the form of dry sweetcorn foliage. The result is shown on page 105. This stage is, of course, optional, being completely down to personal taste.

Materials

Sheet of hot-pressed watercolour paper, 40 x 40cm (15¾ x 15¾in)

HB pencil

No. 6 sable brush with a fine point

No. 12 mixed-fibre brush (optional)

Pencil eraser

Roll of kitchen paper or soft cotton cloth

Watercolour paints in cadmium orange, French ultramarine, cadmium lemon, permanent rose, cadmium red deep, ultramarine violet, cadmium yellow pale, Winsor blue (green shade), cobalt blue and indigo

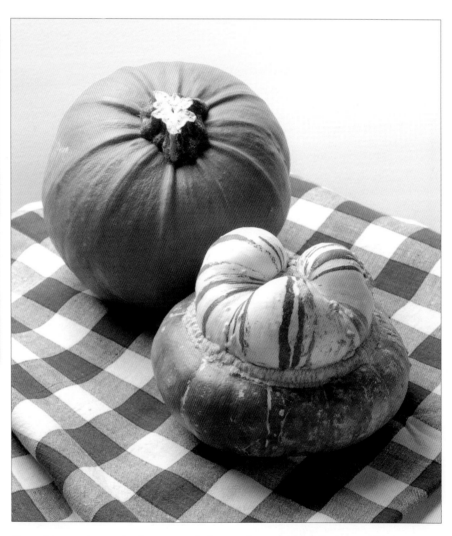

Pumpkins and squash always remind me of autumn celebrations. They come in a huge variety of unusual shapes and textures, giving the painter endless variations on the composition I have chosen to paint here. Pumpkins are generally large in size, making them a challenging subject to paint, but to successfully depict their sumptuous form and surface texture is definitely worth the effort involved.

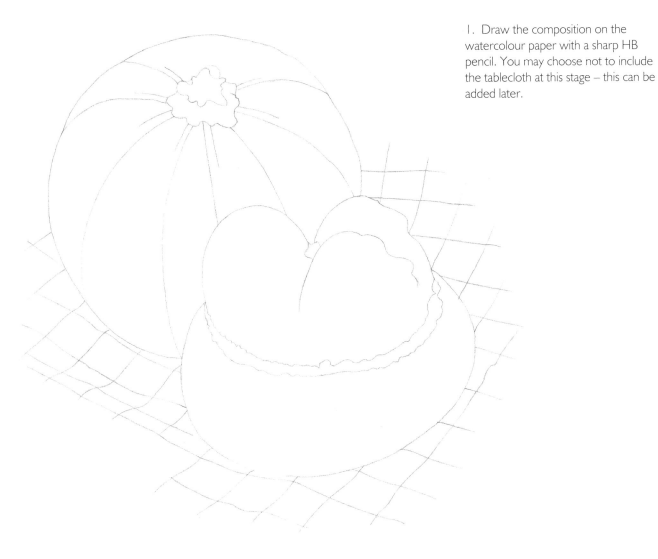

1. Draw the composition on the watercolour paper with a sharp HB pencil. You may choose not to include the tablecloth at this stage – this can be added later.

2. Make two mixes – one of cadmium orange and a touch of French ultramarine to make a dark orange, and a brighter mix of cadmium orange, cadmium lemon and permanent rose. Lay a clear water glaze over one half of the pumpkin (you could use a large, No. 12 mixed-fibre brush to do this).

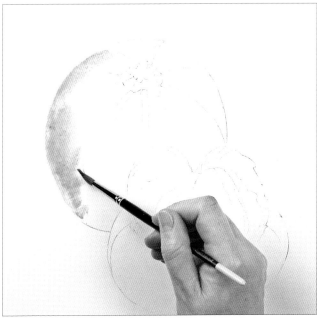

3. While the glaze is still wet, drop on a wash of the dark orange. Load the brush well and get as much colour on to the painting in one go as you can. Lay the colour down the edge and around the base of the pumpkin.

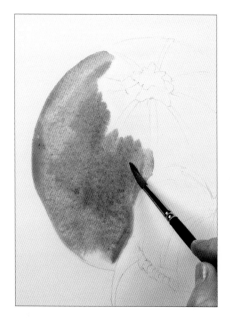

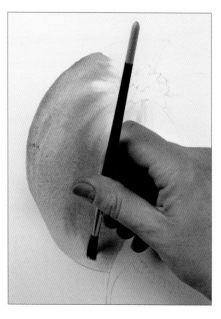

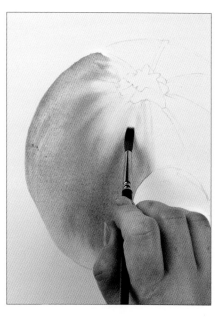

4. Lay the brighter orange mix in the central part of the pumpkin and at the top.

5. Using a clean, damp brush, lift out some of the highlights and reflected light at the top and base.

6. Lift out some of the paint along the left-hand edge, and soften the top of the pumpkin using the full width of the brush. Leave the painting to dry thoroughly.

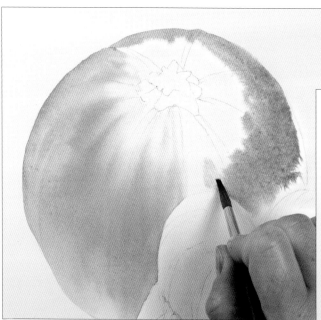

7. Glaze the other half of the pumpkin and drop the dark orange in to the lower part and down the right-hand side. To retain the light, do not take the paint right up to the edge of the pumpkin; leave a little gap.

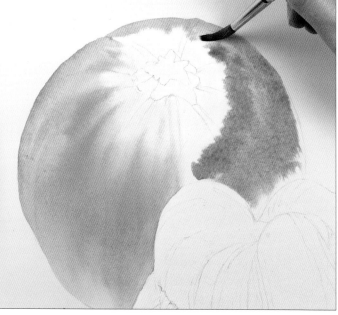

8. Lay the brighter orange mix around the top, and blend the two colours together.

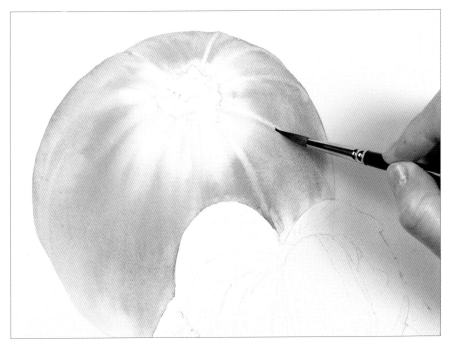

9. Lift out the highlights as before (see steps 5 and 6) and soften the right-hand side of the pumpkin where the paint was kept from the edge.

10. While the paint is drying, make two more mixes – one of cadmium orange on its own, and one of cadmium orange, cadmium red deep and permanent rose. Use these mixes to paint the red area of the Turk's turban squash. Lay a clear water glaze over the area first, then dab on the two colours, mimicking as much as possible the natural pattern on the squash. Leave some areas white.

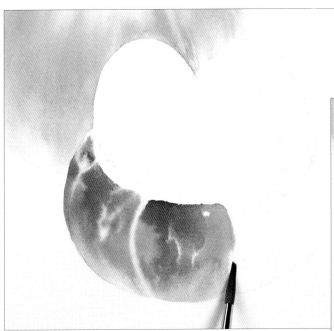

11. Run a clean, damp brush around the base of the squash to soften the orange, and lift out any areas of white that have been painted over.

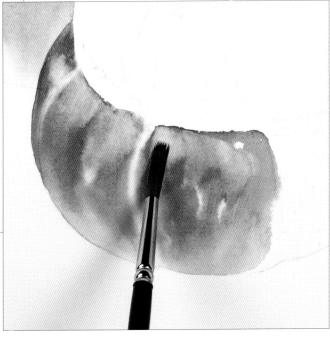

12. When the paint has settled, lift out some of the excess paint at the top of the painted area for the highlights. Allow the paint to dry.

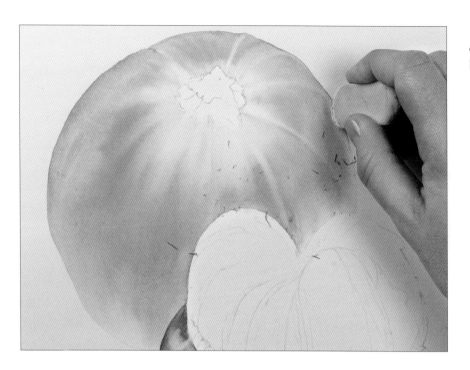

13. When the pumpkin has dried completely, erase any pencil lines you no longer need.

14. Make three more mixes for the squash: cadmium yellow pale and a little cadmium orange to make a strong yellow; a dark green using French ultramarine and cadmium lemon; and a dark orange using the same mix as before (see step 2). When the squash is completely dry, glaze the other half of the base, overlapping it with the dry area slightly so they blend well. Drop a little of the green mix into the first section of the base.

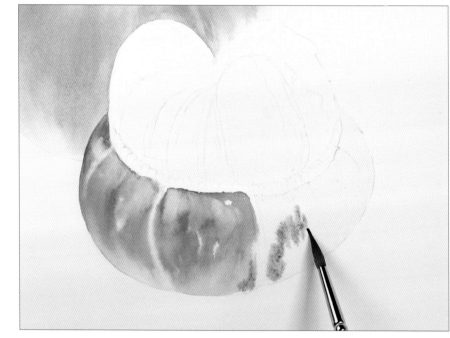

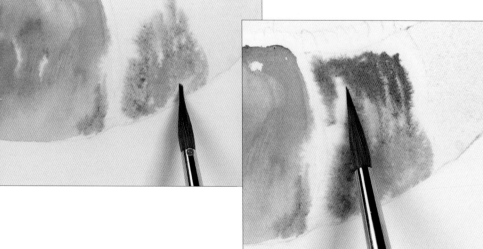

15. Clean the brush and drop in some yellow, then repeat with the orange mix. Mimic the pattern on the squash.

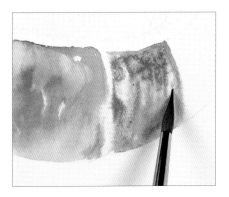

16. Add texture by dropping in small dots of water on to the paint before it dries.

17. Complete the rest of the base in the same way. Work one section at a time, finishing each section at a natural indentation. Allow each section to dry before moving on to the next.

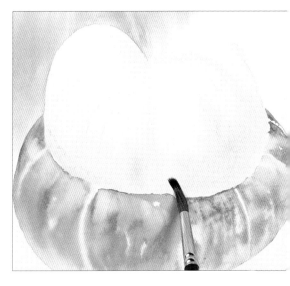

18. For the top part of the squash, mix a little ultramarine violet with some cadmium yellow pale. Glaze the whole area, including the collar, and lay in the paint, avoiding the highlights.

19. While it is drying, use the same mix to paint the cut surface of the stalk on the top of the pumpkin.

20. For the sides of the stalk, use a mix of French ultramarine, cadmium yellow pale and a little cadmium red deep to make an earthy, dark green. Paint the first section on a dry background, applying the paint at the base of the stalk with the tip of the brush and softening it towards the cut surface.

21. On the more textured sections, use small, circular movements with the tip of the brush and leave tiny dots of white for the white speckles. (This is similar to the courgette on pages 62 to 63.)

22. Continue around the remainder of the stalk. Once it is dry, put a wash of cadmium yellow pale over the top.

23. Using the same mix as before (see step 18), strengthen the shadows on the top part of the squash. Soften them in with a damp brush.

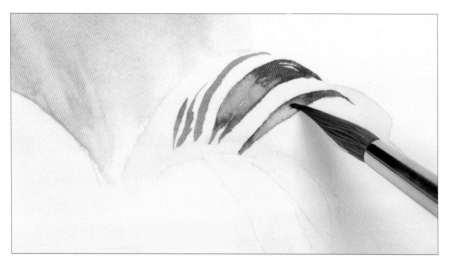

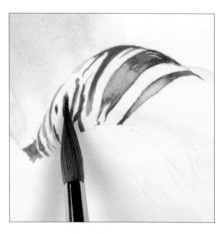

24. Allow the paint to dry, then add the orange and green patterns to the top of the squash. Use a mix of French ultramarine and cadmium lemon for the green, and cadmium orange and permanent rose for the orange. Use the tip of the brush and apply the paint to a dry background. Alternate the colours, and lift out the highlights just before the paint dries.

25. Once it is dry, strengthen the colour where necessary and put in the smaller details.

26. Using a stronger mix of the ultramarine violet and cadmium yellow pale (see step 18), map in the 'warts' on the squash's surface.

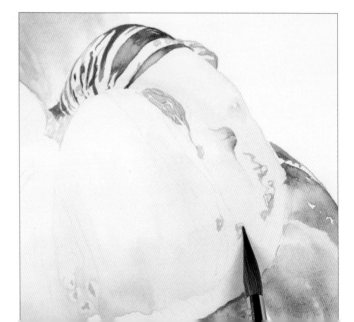

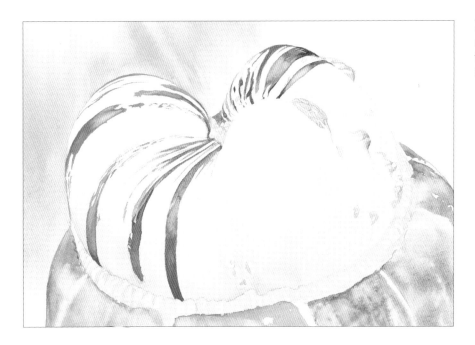

27. Use the same mix to add the detailing around the collar, and complete the orange and red markings on the left-hand side of the top of the squash.

28. When the paint has dried, make a silvery grey mix of French ultramarine, cadmium yellow pale and cadmium red deep and use it to gently encircle each shape on the collar. Soften it to one side of the shape to create shadow.

29. Use the same mix to deepen the shadow just above the collar, and soften it into the background.

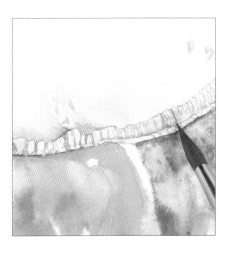

30. Make a gold-coloured mix of cadmium yellow pale and cadmium orange and place it in-between the shapes on the collar.

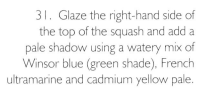

31. Glaze the right-hand side of the top of the squash and add a pale shadow using a watery mix of Winsor blue (green shade), French ultramarine and cadmium yellow pale.

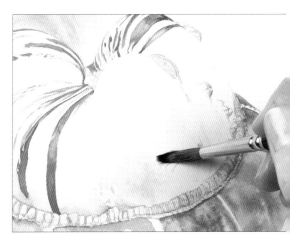

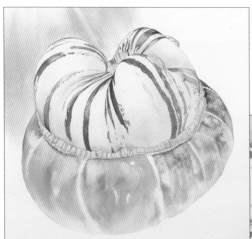

32. When the shadow has dried, complete the red and green stripes as before.

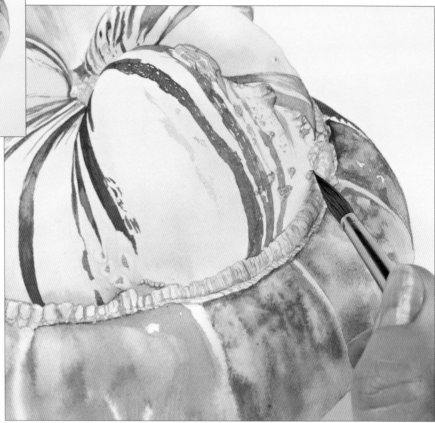

33. Warm up the silvery grey mix (see step 28) with a little more cadmium red deep, and use the very tip of the brush to add the detailing to the 'warts'. Soften with a clean, damp brush.

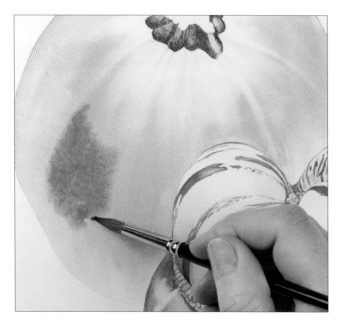

35. Run a clean, damp brush down the outer edges of the section to avoid a hard line forming, and soften the bottom edge of the pumpkin.

34. Returning to the pumpkin, make a strong, wet mix of cadmium orange, French ultramarine and permanent rose. Use this to darken the shaded areas. Work on a section at a time, glazing the area first then dropping in the colour.

36. When the paint has settled, just before it has completely dried, drop small amounts of water into the glaze to create a mottled texture.

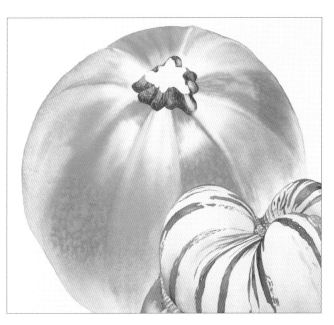

37. Continue round the pumpkin, completing alternate sections in the same way.

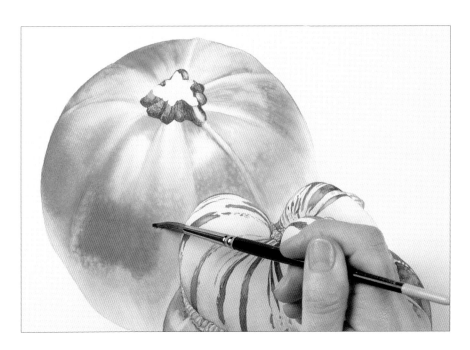

38. When the first sections are dry, complete the sections in-between. Finally, lay a glaze of cadmium orange over the areas that need strengthening and soften it into the body of the pumpkin with a clean brush.

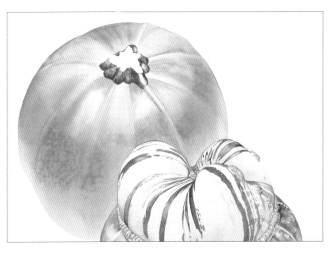

39. Continue to strengthen the colour where necessary, at the same time dragging a little colour over the white highlights to tone them down a little.

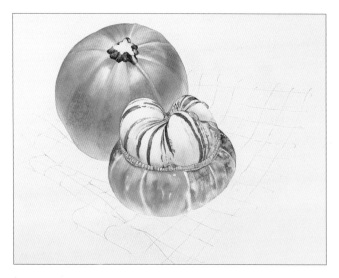

40. Draw in the tablecloth (if you have not already done so).

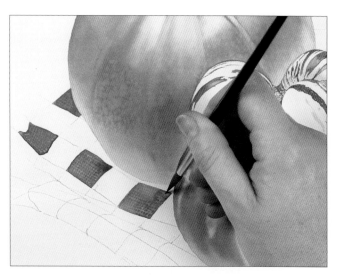

41. Make a mix of cobalt blue and French ultramarine and put in the dark blue squares (do not glaze the background first). Before the paint dries, drag the tip of a clean, damp brush through the glaze to mimic the weave of the fabric.

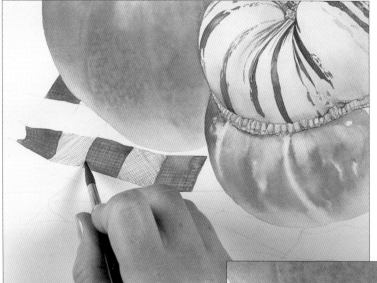

42. Using a mix of French ultramarine and a touch of cadmium red deep, paint in the pale blue squares. Use the tip of the brush to draw in the diagonal lines to define the weave of the fabric, and to outline each square. Work on a dry background.

43. Mix French ultramarine and indigo to make a darker blue and lightly paint in the same pattern over the dark blue squares. Make the pattern darker towards the shaded parts of the fabric.

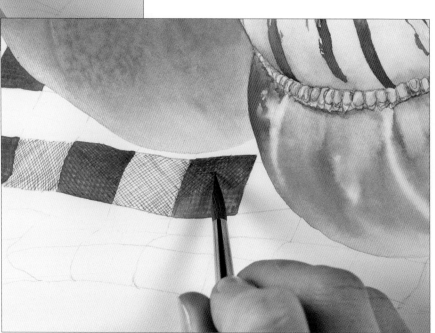

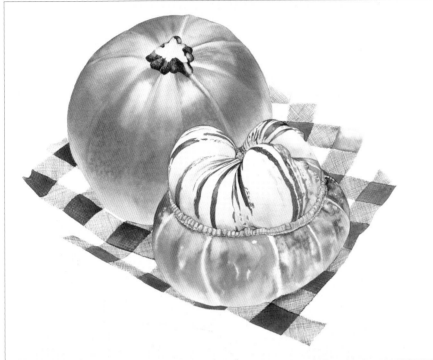

44. Continue to map in the rest of the blue squares, fading them out towards the edge of the painting.

45. Make a mid-tone grey mix of French ultramarine, cadmium yellow pale and cadmium red deep. Water it down so that it is very pale and add a little cobalt blue. Gently lay in the shadows underneath the pumpkin and squash, taking care not to disturb the paint already applied.

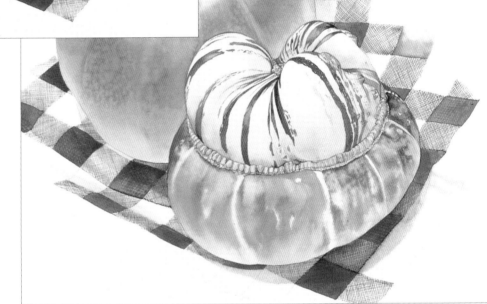

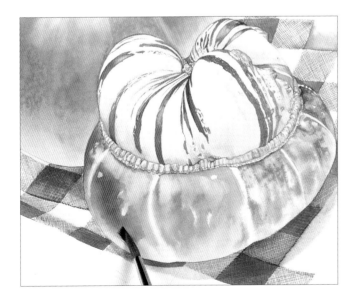

46. Build up the colour on the Turk's turban squash. Using the same two orange mixes as before (see step 10), apply both colours randomly and soften them with a clean, damp brush. Paint around any white highlights. Do not drag the colour too far underneath the squash, otherwise you will lose the reflected light.

101

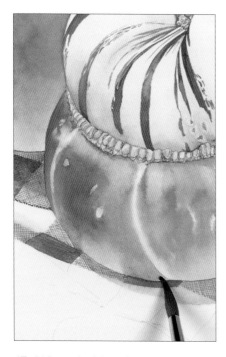

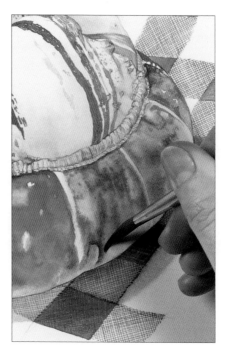

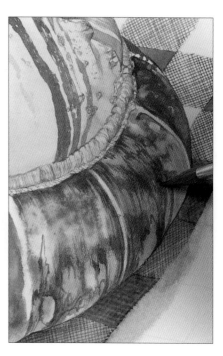

47. Where the blue of the tablecloth is reflected on to the squash, add a faint, watery glaze of cobalt blue.

48. Make the same dark green mix as you used before (French ultramarine and cadmium lemon, see step 14), and begin to strengthen the greens.

49. Using a fairly dry mix of cadmium yellow pale and French ultramarine, and working on a dry background, 'sculpt' the green textured parts of the squash, following the curve of the fruit with your brush. Use the strong yellow mix (see step 14) to strengthen the yellow tones.

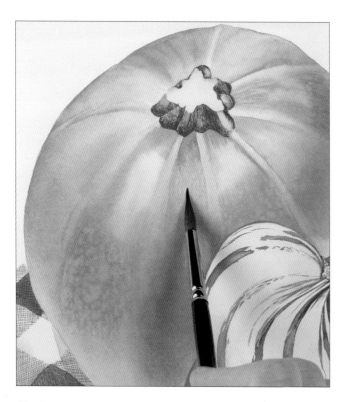

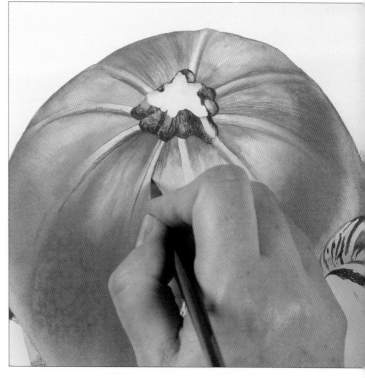

50. Strengthen the colour of the pumpkin. Make a mix of French ultramarine, cadmium orange and permanent rose and paint it on near the neck of the pumpkin, dragging some of the colour down in wavy lines to create texture.

51. Continue to work around the top of the pumpkin. Accentuate the ridges with a mix of cadmium orange and French ultramarine. To define the darker side of each ridge, make fine, wavy lines using the tip of the brush.

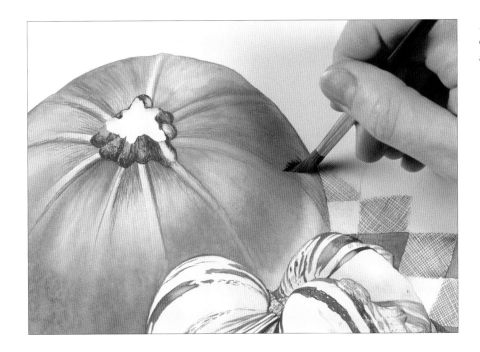

52. Make a bright orange glaze of cadmium lemon and cadmium orange and paint it over the whole pumpkin.

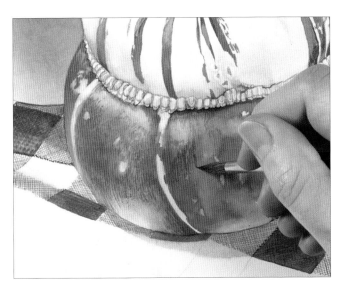

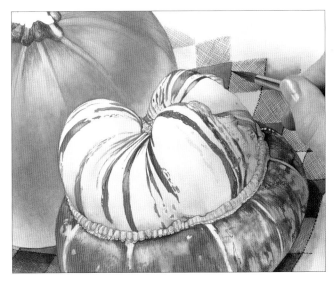

53. Add texture to the orange part of the squash. Make a strong mix of permanent rose and cadmium orange and apply the paint using dry brushing, following the curve of the squash. Take care not to go over the white highlights or patterns.

54. Go over the whole painting, darkening the tone where necessary, for example underneath the squash. Add the black stitching around the squares of the tablecloth using indigo and cadmium red deep.

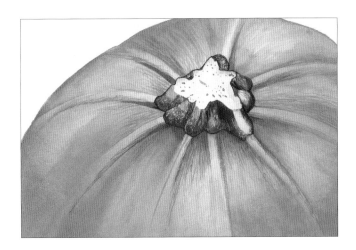

55. Complete the cut surface of the stalk by dotting in the tiny holes using the mid-tone grey (see step 45).

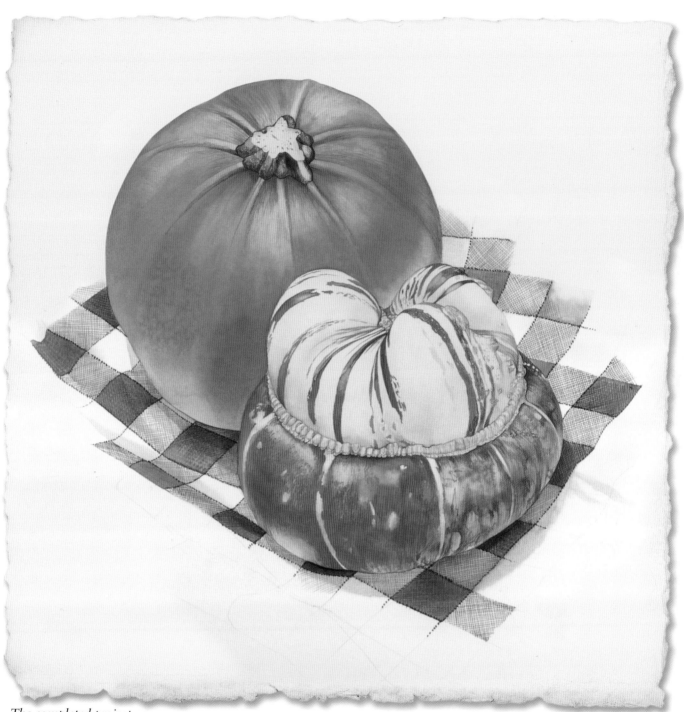

The completed project.

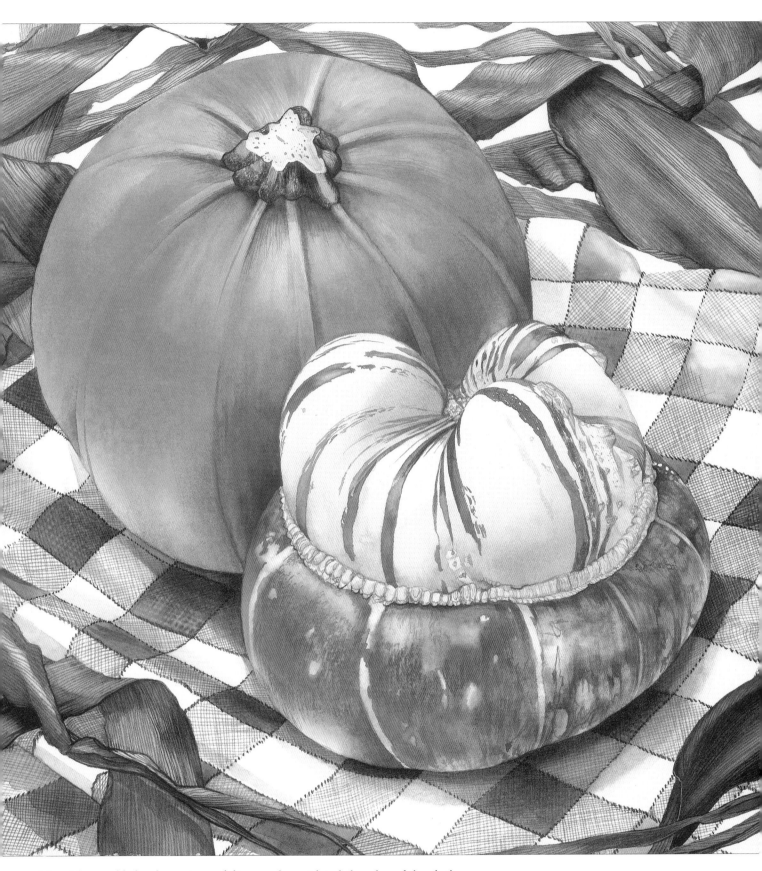

Here I have added red sweetcorn foliage and completed the edge of the cloth. I liked the darkness of the corn leaves as they frame the heavy shapes of the pumpkin and the squash. The colours were created from various mixes of French ultramarine, cadmium red deep, cadmium yellow pale and indigo.

Lemon

This beautiful lemon sat on the top of a box of lemons at my local greengrocer's shop. It was the only one with a leaf and was just what I needed for this project. The lovely, knobbly nature of this lemon is an interesting challenge, and this project is perfect for improving your ability to create form.

The smoothness of the leaf contrasts beautifully with the solid, static lemon both in texture and softness. You will use only two yellows, so the gentle changes in tone and shade will be a good test of your colour mixing skills. When painting with yellow, use as little pencil as possible because the yellow pigment will make the pencil marks permanent.

Materials

Sheet of hot-pressed watercolour paper, 26 x 32cm (10¼ x 12½in)

HB pencil

No. 6 sable brush with a fine point

Pencil eraser

Roll of kitchen paper or soft cotton cloth

Watercolour paints in cadmium lemon, permanent rose, ultramarine violet, cadmium yellow pale, Winsor blue (green shade), French ultramarine, cobalt blue, cadmium red deep and indigo

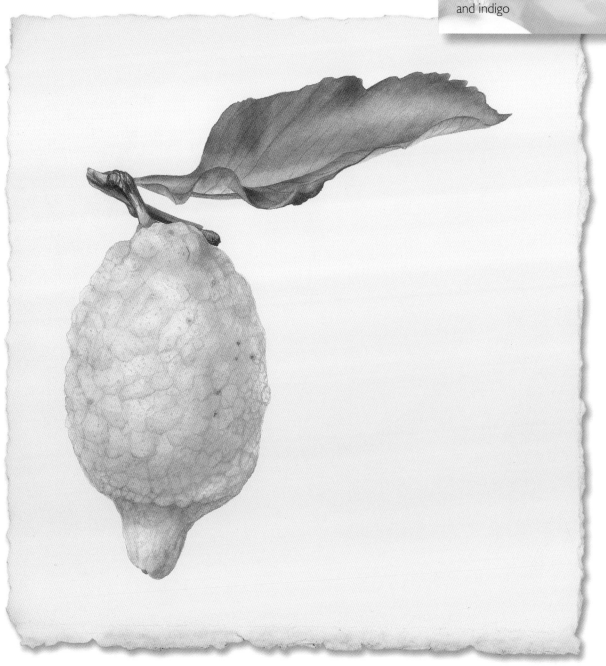

1. Draw the composition on the watercolour paper using a sharp HB pencil.

2. 'Tap into' the line around the lemon with an eraser to lighten the line.

3. Make a soft orange mix using cadmium lemon and permanent rose. Glaze a small area around the top part of the lemon using clear water.

4. While the glaze is still wet, drop small amounts of the soft orange mix into the shaded areas at the top of the fruit. Soften the edges as you work.

5. When the paint has dried, glaze the lower part of the lemon and drop in the colour as before. For the more textured areas, dab the paint on more finely.

6. Begin to build up the surface pattern and texture. Make a pale, watery mix of ultramarine violet and work on the darker, shaded parts of the fruit. Paint in the deeper creases under the surface bumps using the very tip of the brush – draw them on first then soften them, working small areas at a time.

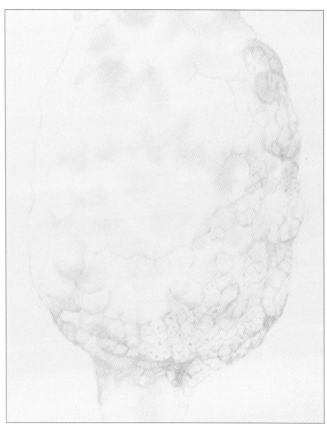

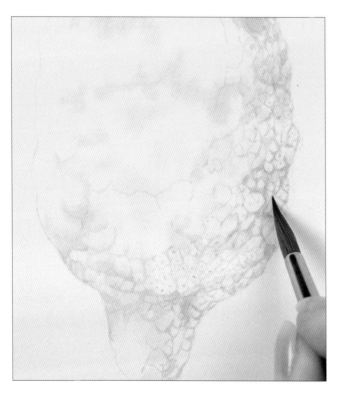

7. As you develop the shaded side of the lemon, start to bring in the pale orange again. Deepen the shadows and go over the violet lines to enhance the texture, and strengthen the existing orange marks where necessary. Avoid painting over the brightest highlights.

8. Work over the remaining areas of the lemon, avoiding the highlights. Paint in the tiny indentations (pores) where you can see them by dotting them in lightly with the tip of the brush. Allow the paint to dry.

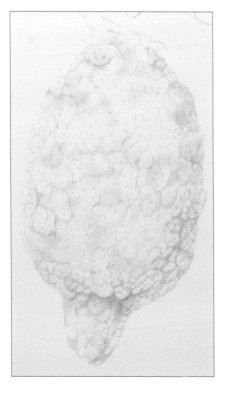

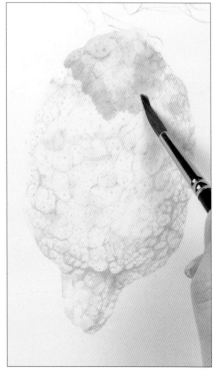

9. You are now ready to lay on the yellow. Make two mixes – one of cadmium lemon and one of cadmium lemon with a little cadmium yellow pale. Working in sections, glaze first with water then apply the two mixes, mimicking the variations in tone on the lemon's surface.

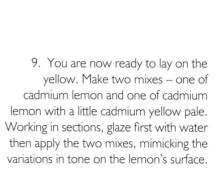

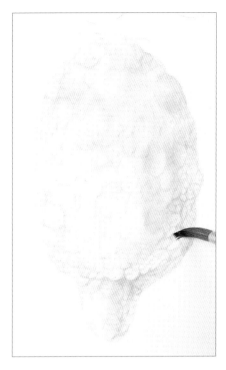

10. Continue to work quickly over the surface of the lemon. Lift out the smaller highlights with a clean, damp brush while the paint is still wet, and soften the leading edges as you work.

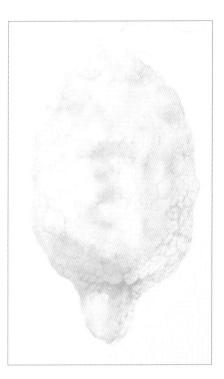

11. Complete the first layer of yellow paint and allow to dry.

12. Make a green mix of cadmium lemon and Winsor blue (green shade), and glaze the area where the small green marks are located. Dot these in with the tip of the brush.

13. Start to strengthen the yellow using a mix of cadmium yellow pale, cadmium lemon and a touch of permanent rose. Build up the colour on the darker areas, softening it as you work.

14. Continue to build up the colour, using at least two or three washes of paint. Allow each area to dry before moving on to the next to avoid over-stressing the paper.

15. Add more cadmium lemon to the lighter, left-hand side of the lemon, applying it in small areas and softening with a damp brush.

16. When you have applied two or three washes of yellow, return to the soft orange mix and start to build up the shadows to enhance the surface texture of the lemon.

17. Continue to apply layers of the yellow mixes – cadmium yellow pale over the shaded areas to intensify them and cadmium lemon on the left. Add any finer detailing, such as the tiny pores and surface blemishes, using the soft orange mix applied with the tip of the brush.

18. Apply another all-over wash of cadmium yellow pale and a touch of permanent rose to intensify the colour of the fruit.

19. For the leaf, make two green mixes: a strong, dark green using French ultramarine, cadmium yellow pale and Winsor blue (green shade), and a lighter green using cadmium yellow pale, cadmium lemon and Winsor blue (green shade). Glaze the upper surface of the leaf using clean water.

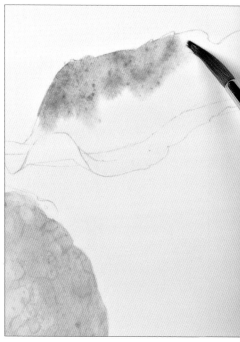

20. Drop in the dark green mix.

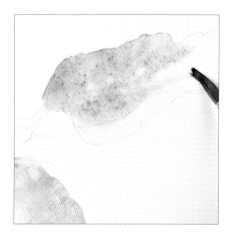

21. Immediately afterwards, while the paint is still wet, drop in the lighter green next to it, allowing the two mixes to blend together on the paper.

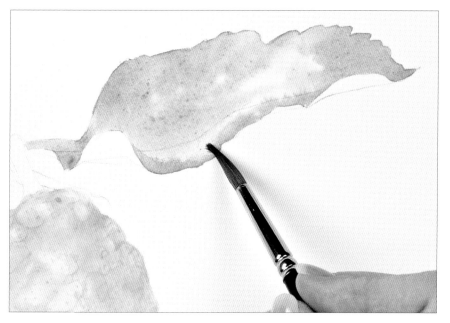

22. Continue to drop in the two greens until the upper surface of the leaf is completely filled. Make sure you work the paint right into the serrations.

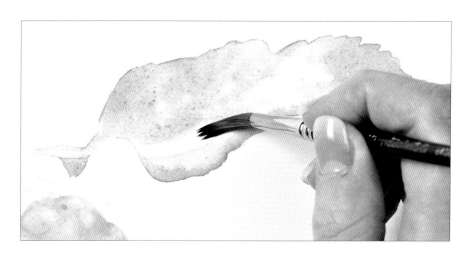

23. While the paint is still wet, lift out the highlights.

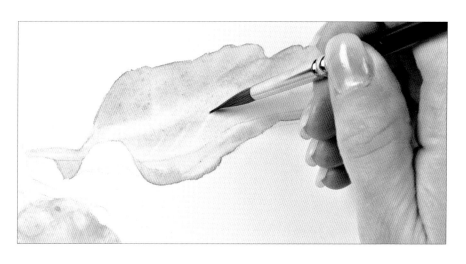

24. Finally, lift out each vein in a sweeping movement using the tip of the brush. Allow the paint to dry completely.

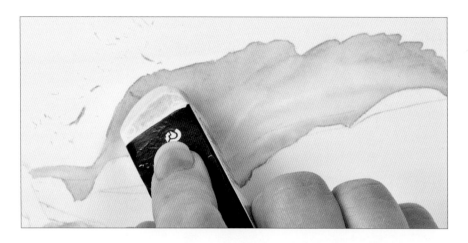

25. Carefully erase the pencil lines you no longer need.

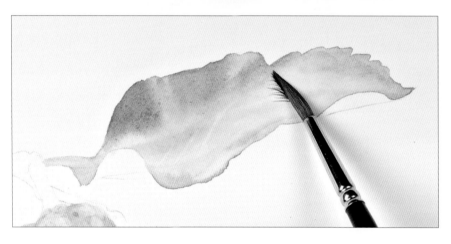

26. Lay another clear glaze over the upper surface of the leaf and use the same green mixes to strengthen the colour where necessary. Allow the paint to dry.

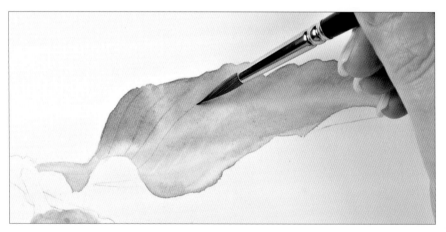

27. Using the tip of the brush, paint on the veins using the darker green mix.

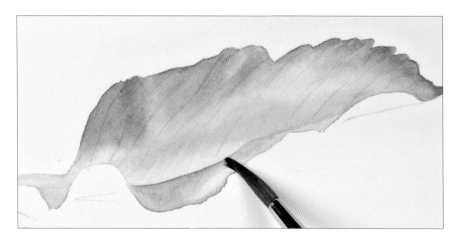

28. Add more colour to define the different sections of the leaf.

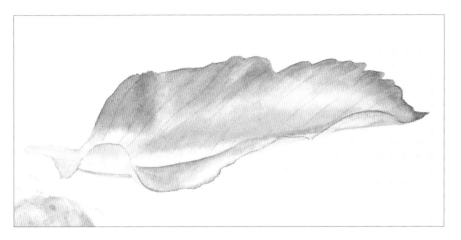

29. Continue building up the colour in certain areas to define the shape of the leaf and to give it form. Use a paler version of the darker green to fill the two small areas of the leaf's underside that are visible. Allow the paint to dry.

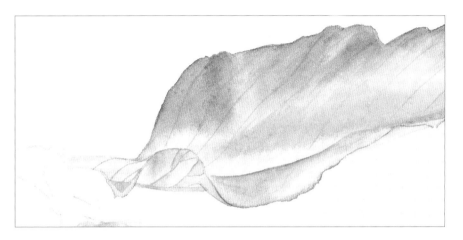

30. Using the tip of the brush, start to put in the finer details, such as the veining on the underside of the leaf.

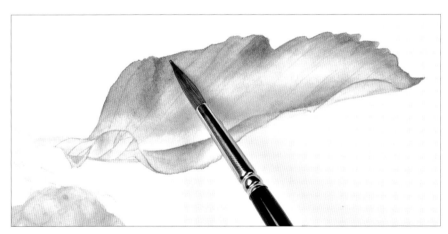

31. Continue building up the colour where necessary with more layers of paint, always softening it in with a damp brush. Where a deeper tone is needed, add a little more French ultramarine to the dark green mix. Allow to dry.

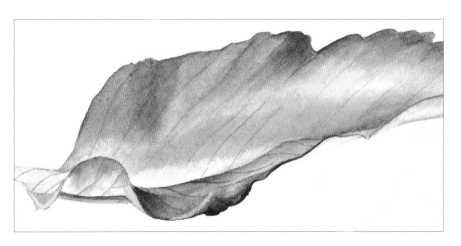

32. Continue adding the darker green to define the curve of the leaf. Use small brushstrokes and soften in the colour with the tip of the brush. For the darkest areas, use a mix of indigo, cadmium yellow pale and a touch of cadmium red deep.

113

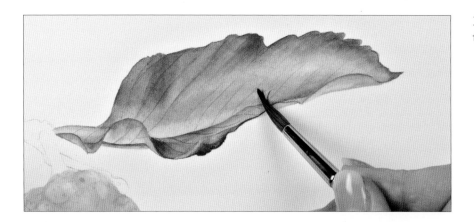

33. Lay a weak wash of cobalt blue over the highlights.

34. Make a mix of cadmium lemon and Winsor blue (green shade) for the lemon stalk. Without glazing first, lay on the colour and lift out the highlight while it is still wet.

35. For the remainder of the stalk use the darker green mix, glazing it first with water.

36. Continue mapping in the greens.

37. Make a brown mix using cadmium red deep, French ultramarine and cadmium yellow pale. Using the dry-brush technique, draw in the details in the stalk using the tip of the brush.

38. Lay a glaze of the pale green mix over the top of the lemon to reflect the green from the leaf.

39. Using ultramarine violet, add more shadow underneath the lemon to accentuate the curve.

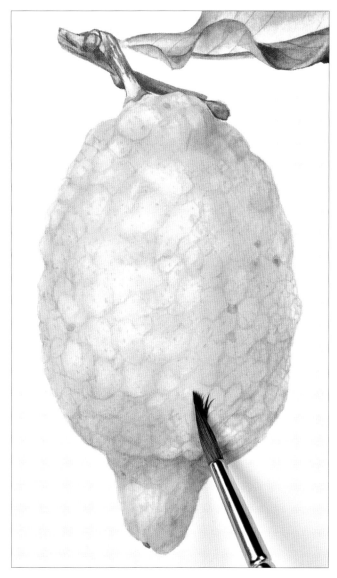

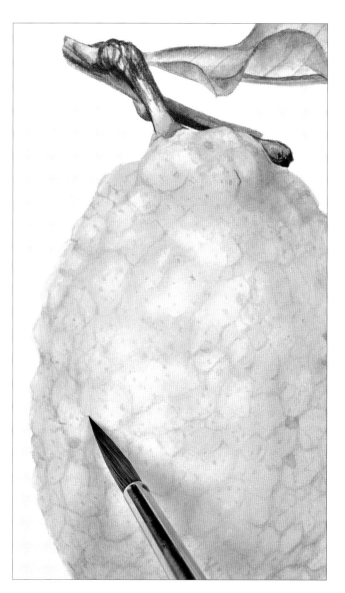

40. Lay a light wash of cadmium yellow pale and permanent rose down the right-hand side of the fruit to emphasise the shadow and create more 'drama'.

41. Remove all the remaining pencil lines, and use a pale mix of ultramarine violet to strengthen the surface textural markings using the tip of the brush where required.

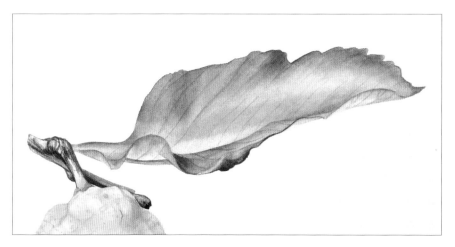

42. Finally, strengthen the leaf with a wash of cadmium yellow pale and Winsor blue (green shade).

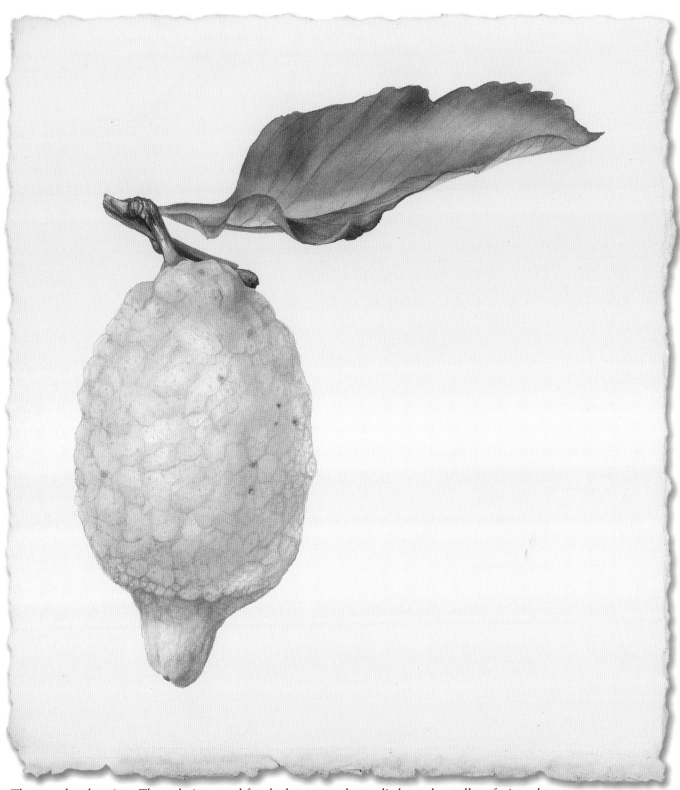

The completed project. The technique used for the lemon can be applied to other yellow fruit and vegetables, for example the bananas on the facing page. Putting the shadows on first means that the shadow mixes do not 'muddy' the yellows.

Bananas
30 x 37cm (11¾ x 14½in)

Bananas would not be everyone's first choice of subject, but they are great fun to paint, though surprisingly difficult as the shadows are very subtle and smooth; layer upon layer of gentle glazes are needed to achieve the soft shadows and changes of colour.

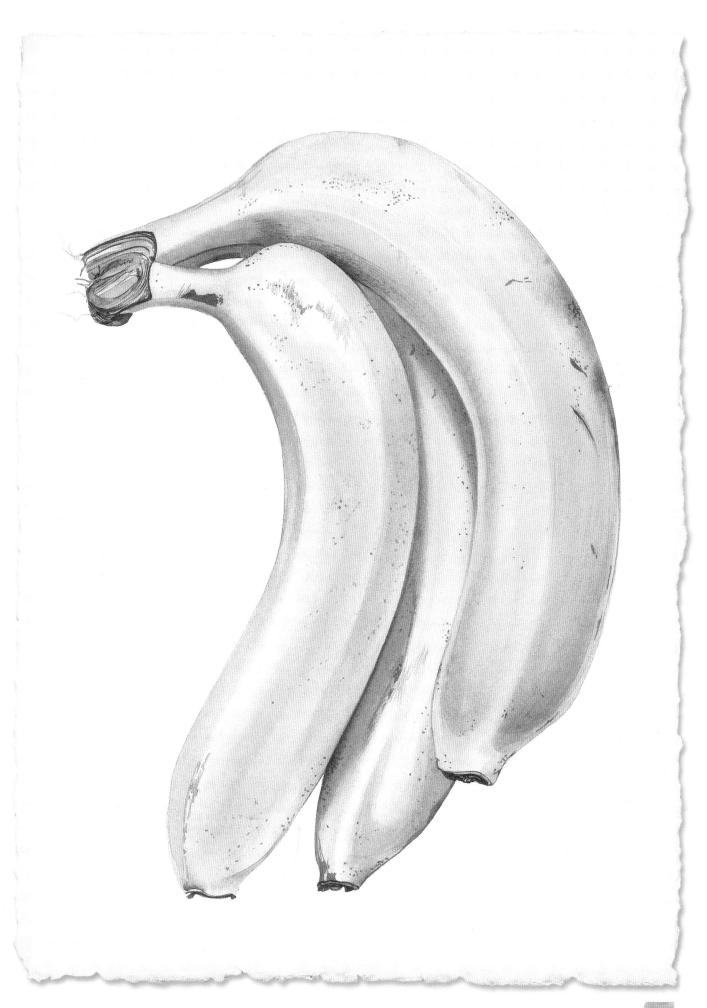

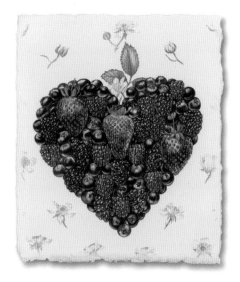

Heart of Berries

This painting will appeal to your romantic side, and is an excellent test of patience and attention to detail. It is created from a selection of berries – you need only three or four examples of each and reproduce them in various positions in the composition. I have used strawberries, blackberries, raspberries and blueberries, but feel free to choose your own selection of your personal favourites. To mimic the reflected light and highlights, group some of the fruits together in a bowl. No initial drawing is provided for this design, as it is built up gradually starting with a few fruit placed randomly in the centre of the heart.

Materials

Sheet of hot-pressed watercolour paper, 33 x 36cm (13 x 14¼in)

HB pencil

No. 4 sable brush with a fine point

Lifting preparation

Pencil eraser

Roll of kitchen paper or soft cotton cloth

Watercolour paints in cobalt blue, cadmium red deep, French ultramarine, cadmium yellow pale, indigo, titanium white, quinacridone red, alizarin crimson, cadmium lemon, Winsor blue (green shade), permanent rose and quinacridone magenta

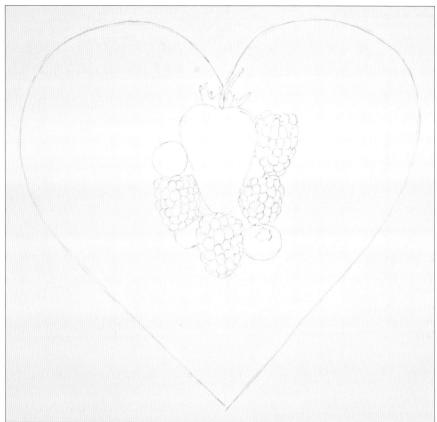

1. Draw the outline for the heart then draw up a small section of the design in the centre of the heart using various fruits. I suggest placing a strawberry in the middle, and arranging the smaller fruits around it.

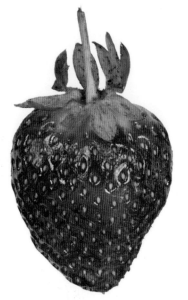

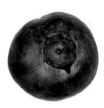

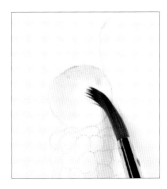

2. Beginning with a blueberry, make a weak mix of cobalt blue and glaze over the fruit with clean water. Drop in the colour at the top and to the left-hand side, where there is a light bloom.

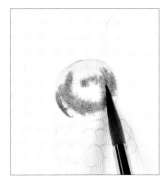

3. While the paint is drying, make a strong mix of cadmium red deep, French ultramarine and a touch of cadmium yellow pale. Glaze over the fruit again with clean water, let it settle, then drop in the darker colour, avoiding the highlights.

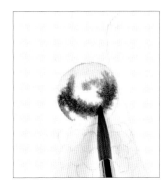

4. Put in as much colour as you can. Be careful not to lose the highlights.

5. With a clean, damp brush, soften the edges and make sure the paint does not bleed into the highlights.

6. While the paint is drying, use the tip of the brush to move the dark colour to where you want it, including the points along the top edge of the berry.

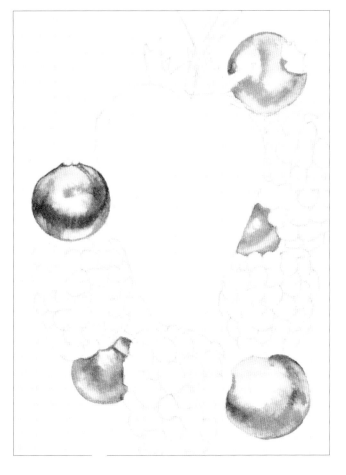

7. Map in the remaining blueberries in the central section in the same way.

8. Using the same dark mix, glaze a single globe (drupelet) of one of the blackberries with water, drop in the colour then lift out the highlight.

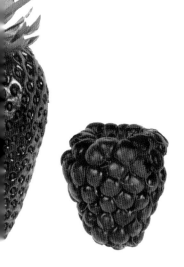
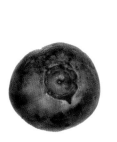
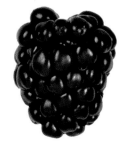
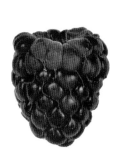
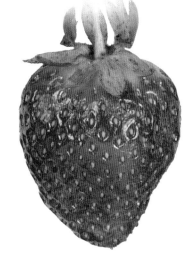

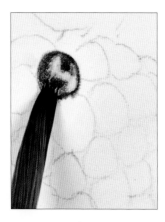

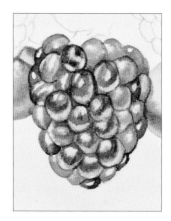

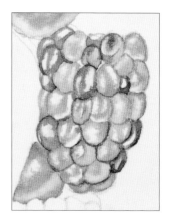

9. When the paint has dried, gently dry brush in some stronger colour using a drier mix.

10. Move from one drupelet to the next, using the same method of applying colour.

11. Complete the remaining blackberry drupelets in the same way.

12. Complete the remaining blackberries to the same stage.

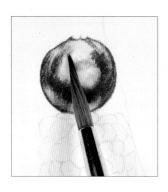

13. Returning to the first blueberry, make a very strong mix of indigo and cadmium red deep. Apply the paint with the tip of the brush to build up the dark colour of the fruit. Use dry brushing to achieve the darkest tone possible.

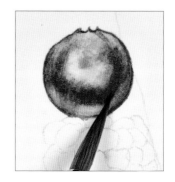

14. Dampen the end of the brush and soften any hard edges for a more natural look. Sharpen the details.

15. Build up the remaining blueberries in the same way.

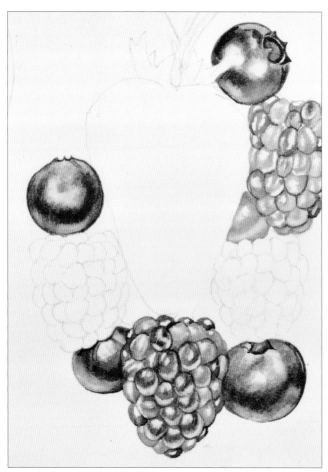

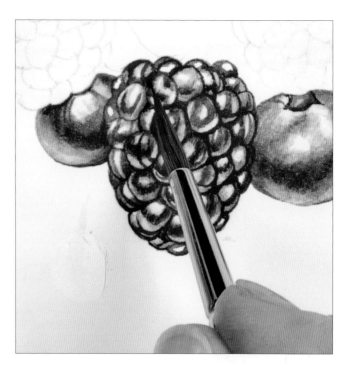

16. Returning to the blackberries, use the same strong mix to build up the darkest areas using the tip of a dry brush.

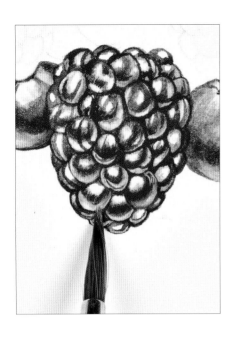

17. Place a little titanium white on the underside of each drupelet in the lower half of the fruit. This produces a light blue bloom of reflected light.

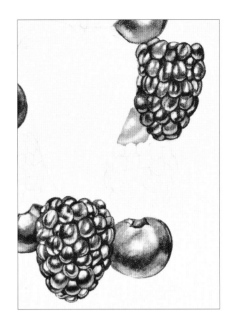

18. Build up the remaining blackberries in the same way.

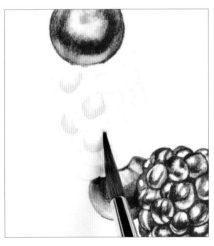

19. Turning now to one of the raspberries, make a mix of quinacridone red. Glaze three or four drupelets, then drop in the pink glow around the base of each one.

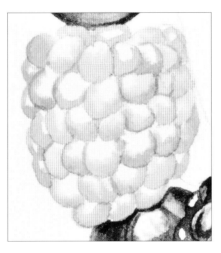

20. Apply colour to the rest of the raspberry, working on three or four drupelets at a time.

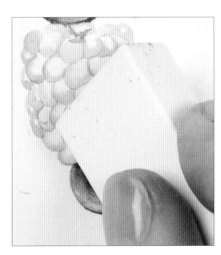

21. Once dry, erase any visible pencil marks from the raspberry.

22. Make a mix of quinacridone red, alizarin crimson and a touch of cadmium yellow pale. Gently paint in the reflected red between the drupelets.

23. Glaze the whole fruit with water – this will lift some of the colour out and on to the highlights.

24. Lift out any highlights that have been lost. Do this by wetting the area to be lifted out, then just as it is drying, dab with kitchen towel.

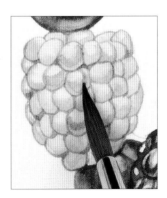

25. Using a very pale mix of quinacridone red and cobalt blue, paint the shadow on each drupelet. Work on two or three at a time, then soften with a damp brush.

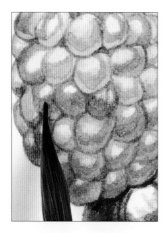

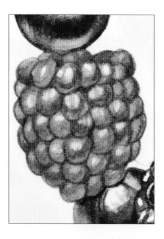

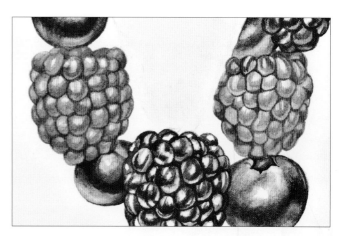

26. Make a watery mix of quinacridone red and work softly round the highlights, strengthening the colour.

27. Continue building up the colour until the fruit looks bright and juicy.

28. Paint the other raspberries in the same way.

29. Once the paint has dried, begin working on the strawberry. Glaze the berry with two or three layers of lifting preparation, allowing each layer to dry before applying the next. (The lifting solution stops the paint from adhering to the paper, allowing it to lift off cleanly.)

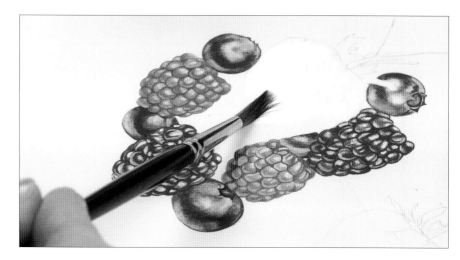

30. While the lifting preparation is drying, mix the colour for the strawberry leaves using cadmium lemon and Winsor blue (green shade). First glaze the leaves, then place the green at the top and the bottom.

31. Continue to add bright green wherever you can see it and allow the paint to dry. Make a darker green with French ultramarine and cadmium yellow pale. Glaze the leaves again and drop a small amount of dark green into the centre of the leaves.

32. Remove any visible pencil lines you no longer need and continue placing the darker green.

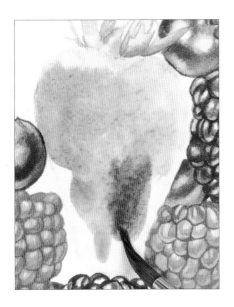

33. While the leaves are drying, mix the colours for the strawberry – cadmium lemon, quinacridone red and a hint of Winsor blue (green shade) for the pale green at the top; quinacridone red and cadmium lemon for the middle section; and cadmium red deep and permanent rose for the lower part. Make the mixes quite watery and apply them in quick succession, starting at the top.

Tip

Every fruit is different, and you may need to vary these mixes a little when working on the next strawberry.

34. Continue dropping in colour. While the paint is still wet, soften the edges with a damp brush, lift out the highlights and sharpen the outline of the strawberry. Allow the paint to dry.

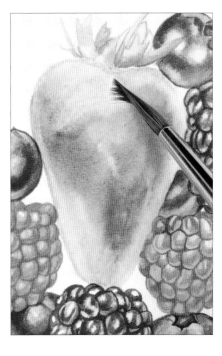

Tip

Position the seeds carefully, making sure you get the size and angle of each one correct.

35. Lift off the paint to define the position of each seed. First, gently place just the tip of a damp brush on the paper.

36. Next, dab off the paint with a clean kitchen towel.

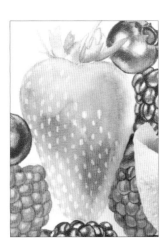

37. The paint should lift off cleanly and neatly.

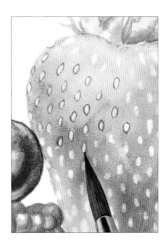

38. Using a strong mix of quinacridone red and alizarin crimson, put a bright, juicy shadow around each seed. Apply the paint with the tip of the brush.

39. For the lower seeds, paint only around the top of the pips, which is where the shadows lie, due to the reflected light.

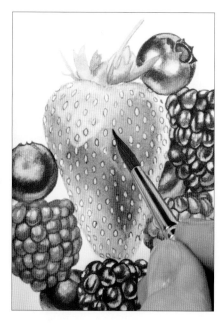

40. Lift out the highlights in between the seeds. As before, first dampen the area gently using the very tip of the brush (make sure the brush is not too wet).

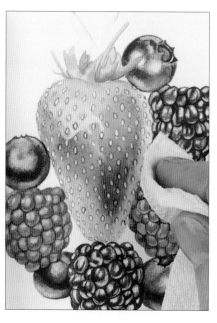

41. Immediately lift off the paint with a kitchen towel.

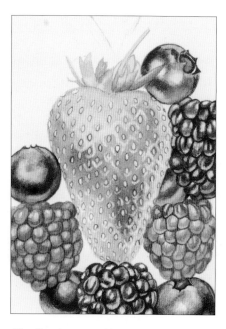

42. Continue working your way down the fruit, observing carefully and lifting out the highlights where you can see them.

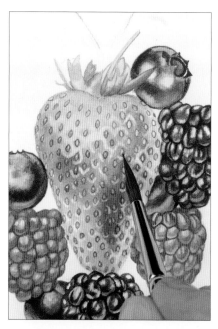

43. Colour in the seeds using a mix of cadmium yellow pale and cadmium red deep; for the younger pips at the top of the strawberry use cadmium yellow pale and a touch of Winsor blue (green shade). Gently drop the paint in, being careful to leave a tiny highlight on each seed (the position of the highlight changes as you move round the fruit).

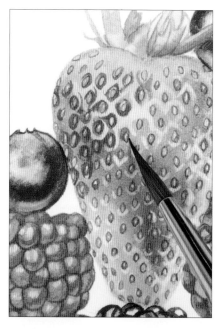

44. When all the seeds have been mapped in, start to build up the colour around them. Use a mix of quinacridone red, permanent rose and a touch of cadmium yellow pale to give a fresh, pinky red.

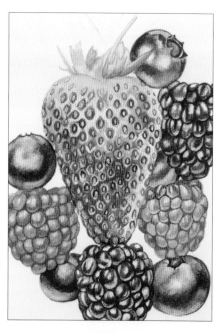

45. Continue to build up the red, changing the strength and pattern of the paint depending on what you can see. For small areas, use a very dry brush as too much water will dislodge the paint.

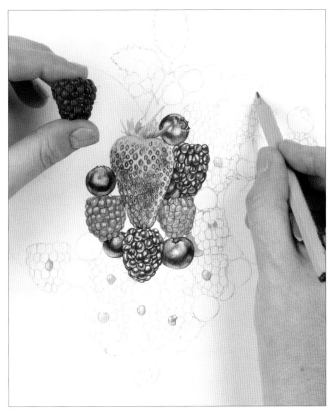

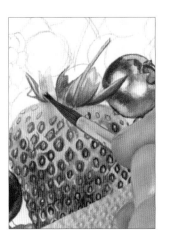

46. Draw in some more berries, and plan out the colours by painting a single drupelet on each raspberry and blackberry. Draw in the leaf at the top of the heart.

47. Mix together French ultramarine, cadmium yellow pale and Winsor blue (green shade) and, using dry brushing, start to build up the darker green on the strawberry leaves. Rest your hand and arm on a piece of kitchen towel to avoid smudging your drawing.

48. Water down some of the mix and blend it into the colour at the top of the strawberry, underneath the leaves. Make a thick mix of titanium white and cadmium lemon and dry brush it on to suggest the tiny, subtle hairs on the underside of some of the strawberry leaves.

49. Moving now to the blossom at the top of the heart, make a watery mix of cadmium lemon and Winsor blue (green shade) and draw in the stamen. Use cadmium yellow pale to dot in the stamen tips.

50. Make a very pale, watery mix of permanent rose and quinacridone red. Glaze one petal at a time with clear water then drop in the paint to create a gentle pink blush. Add a touch of bright green around the base of the stamen to indicate sepals.

51. Make a grey mix of French ultramarine, cadmium red deep and cadmium yellow pale. Water it down until the colour is barely there and paint in the shadows on the petals. Paint in the green stem with the same mix.

52. For the leaves, make two mixes – one of cadmium yellow pale and Winsor blue (green shade) and one with some French ultramarine added to create a deeper green. Glaze the leaf with water, ensuring the water goes right into the serrations, then drop in the lighter of the two greens towards the tip.

53. Quickly drop in the darker green towards the base of the leaf, allowing the two greens to blend on the paper.

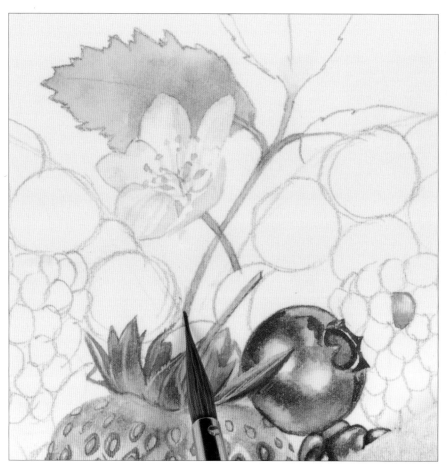

54. Pull the darker green into the stems.

55. Use the tip of the brush and the darker green to paint in the veins and sharpen up the serrations.

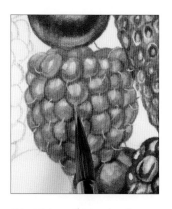

57. Make a thick mix of titanium white and cadmium yellow pale and use the tip of the brush to paint in the tiny hairs on the raspberries.

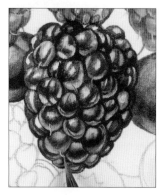

58. For the blackberry hairs, use a thick mix of cadmium red deep, cadmium yellow pale and a touch of titanium white. Make them slightly shorter than the hairs on the raspberries, and less prominent. Highlight some of the hairs with a touch of titanium white.

56. Dry brush the darker green over the veins to give texture to the leaf. Mix a little pale brown using alizarin crimson and cadmium yellow pale and drop some colour into the serrations. Drag it down either side of the mid rib and into the stem, and add some thorns.

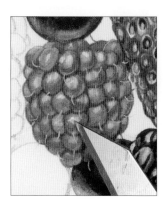

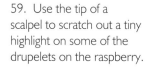

59. Use the tip of a scalpel to scratch out a tiny highlight on some of the drupelets on the raspberry.

To complete the painting, the areas in-between the berries were painted in using quinacridone magenta and permanent rose. I have dotted blackberry blossom around the heart to create a pretty background, but this stage is, of course, optional.

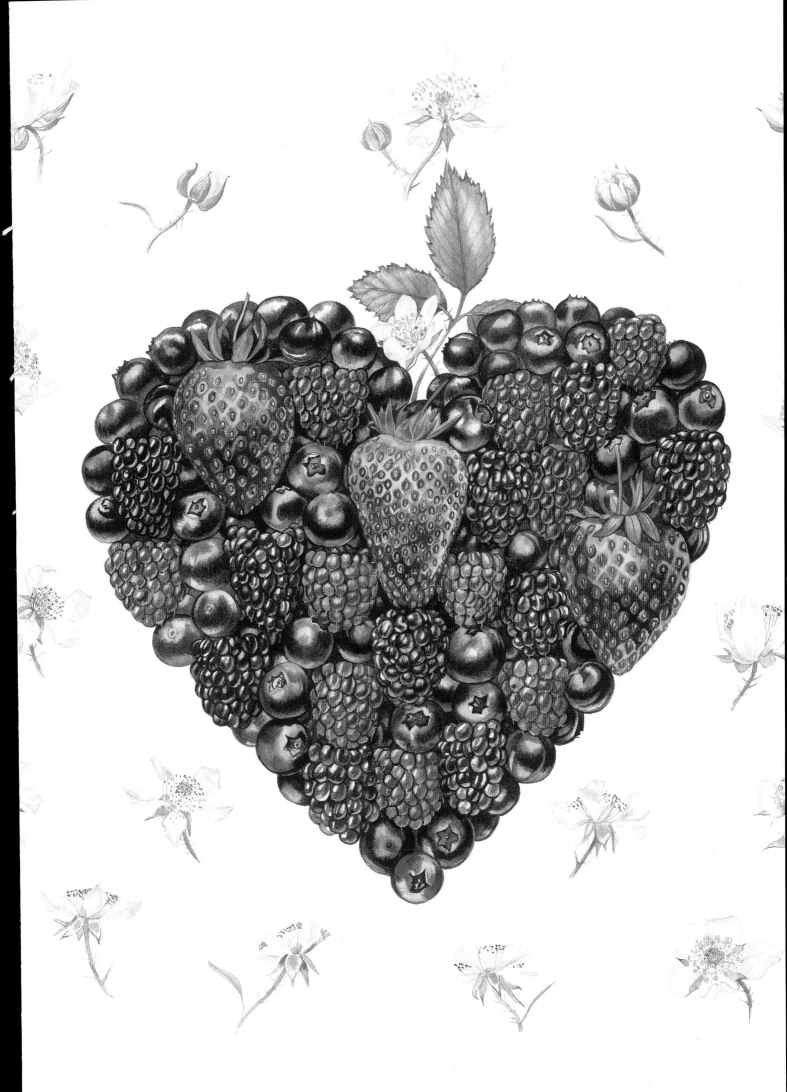

Index

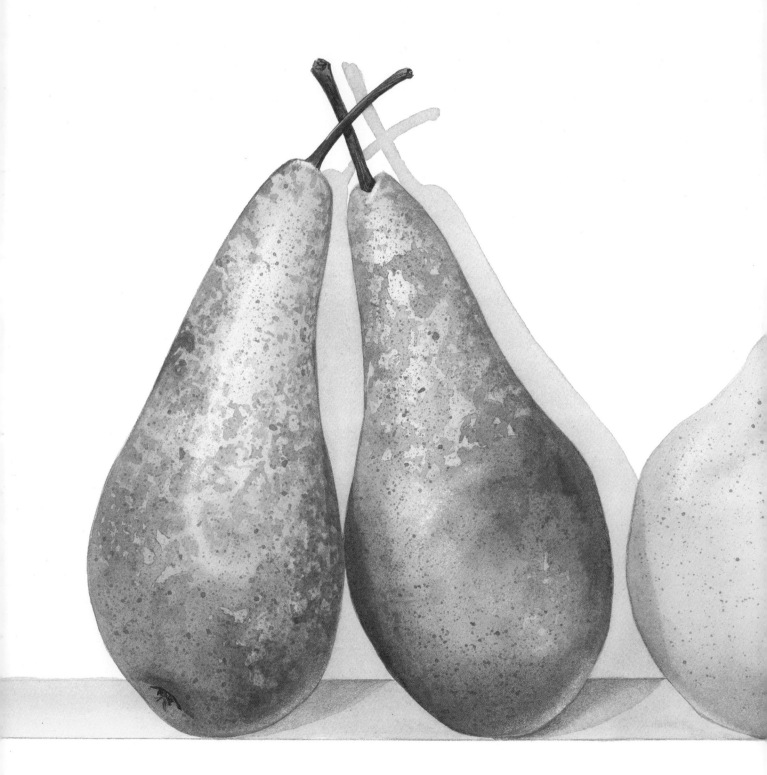